ALWYN
CRAWSHAW
PAINTS
ON HOLIDAY

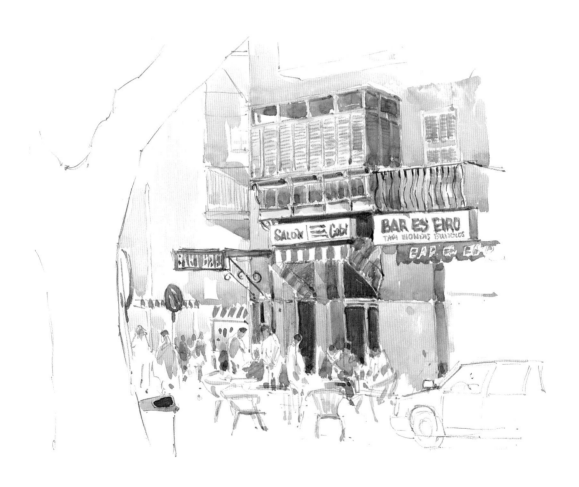

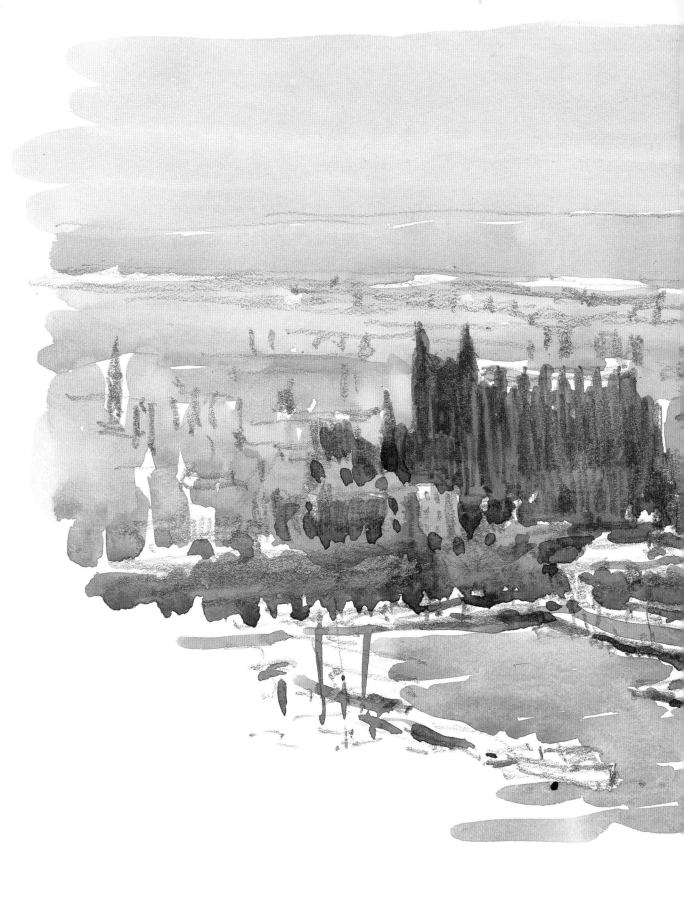

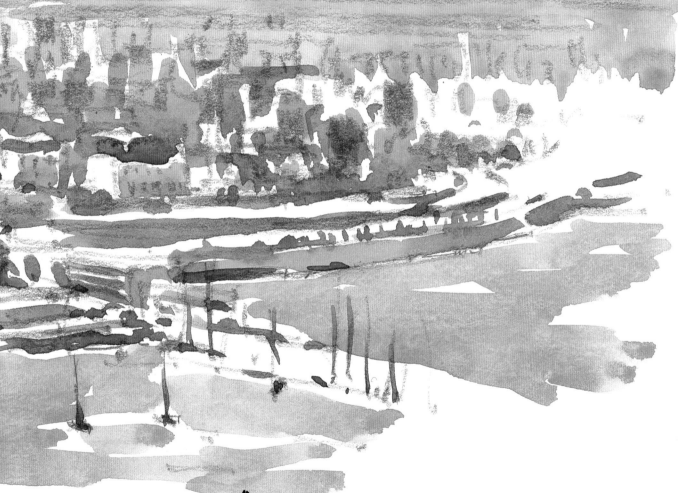

ALWYN
CRAWSHAW
PAINTS
ON HOLIDAY

North Light Books
Cincinnati, Ohio

First published in U.S.A. in 1993 by
North Light Books, an imprint of
F&W Publications, 1507 Dana Avenue,
Cincinnati, OH 45207 (1-800-289-0963)

First published in the UK in 1992 by
HarperCollins Publishers
London

© Alwyn Crawshaw, 1992

CONSULTANT EDITOR:
Flicka Lister

DESIGN & TYPESETTING:
Terry Jeavons

PHOTOGRAPHY:
Nigel Cheffers-Heard
LOCATION PHOTOGRAPHS:
David John Hare, Alwyn Crawshaw
and June Crawshaw

The author asserts the moral right to be
identified as the author of this work.

**A catalogue record for this book is
available from the British Library**

Jacket photograph of the author by
Nigel Cheffers-Heard
Title page: *Palma Cathedral* in watercolour
(actual size 20 × 28 cm/8 × 11 in)

ISBN 0-89134-538-8

Printed and bound in the UK

ACKNOWLEDGEMENTS

I would like to express my grateful thanks
to all the people that June and I met on
our holiday travels who were so helpful.
Also to the team who made the TV series
and, in particular, David John Hare the
producer, Ingrid Duffell the director,
TSW for their tremendous support, and
the Majorcan Tourist Office for their
considerable help.

I would like to record my sincere
thanks to Cathy Gosling from
HarperCollins and to Flicka Lister for
editing this book.

Finally to June, my wife, who has
contributed so successfully with her work
and her painting to the holidays, television
series and this book.

The six-part television series, *Crawshaw Paints on
Holiday,* was produced by David John Hare.

CONTENTS

PORTRAITS OF THE ARTISTS

Alwyn Crawshaw

Successful painter, author and teacher Alwyn Crawshaw was born at Mirfield, Yorkshire, and studied at Hastings School of Art. He now lives in Dawlish, Devon, with his wife June, where they have opened their own gallery. As well as painting in watercolour, Alwyn also works in oils, acrylics and pastels. He is a fellow of the Royal Society of Arts and a member of the Society of Equestrian Artists and the British Watercolour Society.

Alwyn's best-selling book *A Brush with Art* accompanied his first 12-part Channel Four television series in 1991. This book, *Crawshaw Paints on Holiday*, accompanies his second 6-part Channel Four series and *Crawshaw Paints Oils* is the third Channel Four television series with a tie-in book of the same title.

Alwyn's previous books for HarperCollins include eight in their *Learn to Paint* series, *The Artist at Work* (an autobiography of his painting career), *Sketching with Alwyn Crawshaw, The Half-Hour Painter, Alwyn Crawshaw's Watercolour Painting Course* and *Alwyn Crawshaw's Oil Painting Course*.

Alwyn has been a guest on local and national radio programmes, including *The Gay Byrne Radio Show* in Eire, and has appeared on various television programmes, including BBC Television's *Pebble Mill at One, Daytime Live* and *Spotlight South West*. Alwyn has made several succesful videos on painting and in 1991 was listed as one of the top ten artist video teachers in America. He is also a regular contributor to *Leisure Painter* magazine. Alwyn organises his own painting courses and holidays as well as giving demonstrations and lectures to art groups and societies throughout Britain.

Fine art prints of Alwyn's well-known paintings are in demand worldwide. His paintings are sold in British and overseas galleries and can be found in private collections throughout the world. Alwyn has exhibited at the Royal Society of British Artists in London, and he won the prize for the best watercolour on show at the Society of Equestrian Artists' 1986 Annual Exhibition. He is listed in the current edition of *Who's Who in Art*.

Heavy working horses and elm trees are frequently featured in Alwyn's paintings and may be considered the artist's trademark. Painted mainly from nature and still life, Alwyn's work has been favourably reviewed by critics. *The Telegraph Weekend Magazine* reported him to be 'a landscape painter of considerable expertise' and *The Artist's and Illustrator's Magazine* described him as 'outspoken about the importance of maintaining traditional values in the teaching of art'.

June Crawshaw

Surrey-born June Crawshaw is a member of the Society of Women Artists and the British Watercolour Society. She has had numerous exhibitions of her paintings and her original work can be found in many art collections. June is listed in the current edition of *Who's Who in Art* and she teaches watercolour painting alongside Alwyn on their residential courses. Her paintings are sold throughout Britain and also in the family gallery in Dawlish.

INTRODUCTION

When I first saw this Majorcan lighthouse, I did a quick sketch of it in biro on the back of a postcard (see page 47). Then later, on a rainy day, I used it as inspiration for working indoors.
Oil on primed hardboard, 25 × 30 cm (10 × 12 in)

Doesn't the subject of this book, 'painting on holiday', excite you? It does me! The thought of going somewhere completely different to your home surroundings and not having to worry about work or household chores for a while is always exciting, but if you paint it means so much more.

On holiday, you can relax in a world where you won't constantly be interrupted by the telephone, the door bell, or any of the countless other activities that are part of our daily routine. Above all, being able to paint without the normal pressures of home or work means that you can start and finish a painting when *you* decide, rather than be dictated to by the school bell, the garden, the kitchen door handle that needs attention, or the empty bread bin!

As I write this, I'm getting quite nostalgic and my memory is working overtime, going over all the fabulous times I have had on holiday, painting with June, my wife, who is also an artist. However, like all things in life that would appear perfect, painting holidays need careful thought and planning. So, from my experiences and those of the students I have taught, I hope to give you all the information and help I can in this book. Incidentally, the fact that I am a professional doesn't make me any different when it comes to holidays. At home I am interrupted just as often as any leisure painter and therefore, like you, I don't always have control of my painting time. As a result, I get just as excited as a little boy when we are to go on holiday!

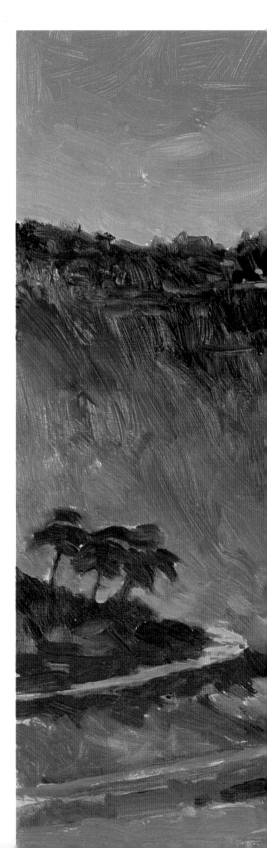

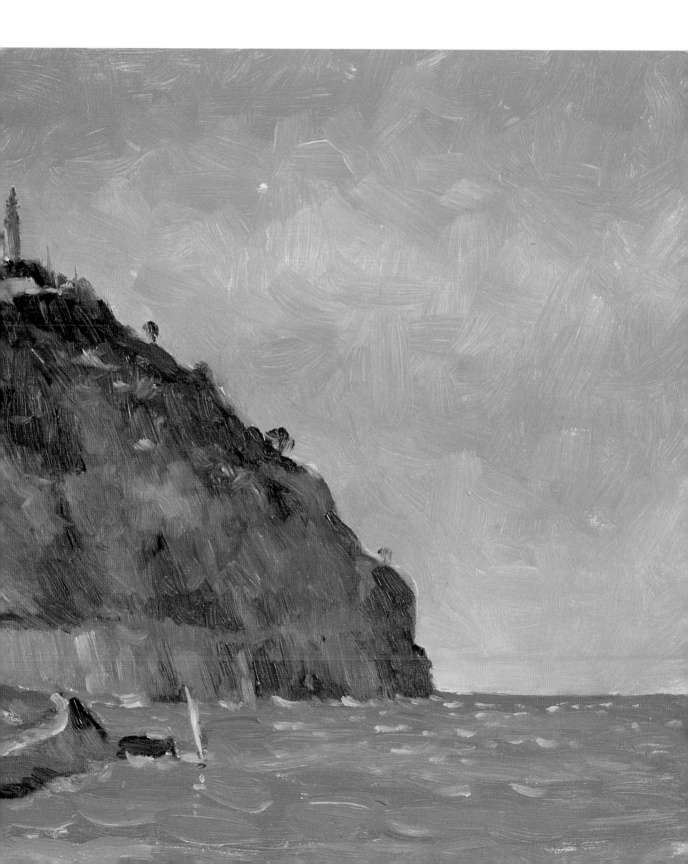

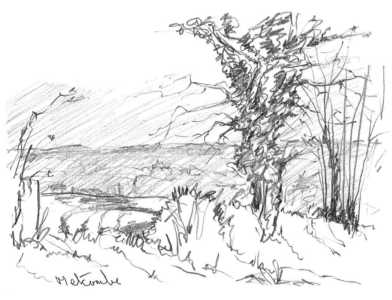

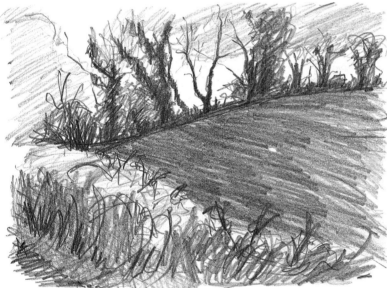

The pencil has a tremendous range of tones, from almost 'black' to very light grey. Here June has used the dark tones of the pencil to contrast with the white of the paper, giving the effect of sunlight behind the trees.

Pencil on cartridge, 13 × 18 cm (5 × 7 in)

In this pencil sketch, June has used the white paper to create strong February sunlight.

Pencil on cartridge, 13 × 18 cm (5 × 7 in)

There are many different types of holiday, and I have simplified these by dividing them into groups in this book. In each group I have used real-life holiday situations that June and I have been in, relating those situations to the paintings that are illustrated and also explaining the important features of the paintings. Some of June's paintings are reproduced alongside mine and these will show you how two artists can think and work differently. So, with a little imagination, you will be able to look over our shoulders while we paint and share some of our holiday experiences and our paintings with us.

Even on holiday there are times when you will have to paint under a certain amount of pressure. The first section of this book, entitled 'TV Painting Holiday' is a perfect example of this. It describes what happened when June and I went with a television crew to Majorca to film my TV series, *Crawshaw Paints On Holiday*, in which you can see June and me sweat under the camera – and not *always* from the sun! Although you may never be called upon to sketch or paint in circumstances like this, in front of television cameras, I hope you will benefit from sharing our experiences.

I have called the second section 'A Day Out' and it really is as simple as that. This can be a day that has been planned, or a spontaneous 'spur-of-the-moment' painting trip. The latter are often perfect days out – since nothing has been planned, far less can go wrong! June and I have had a some wonderful days like this. You haven't visualised in advance what you want to paint and therefore you are more likely to accept what you find when you get to the location. My pencil sketches of Dartmoor ponies, *right*, were

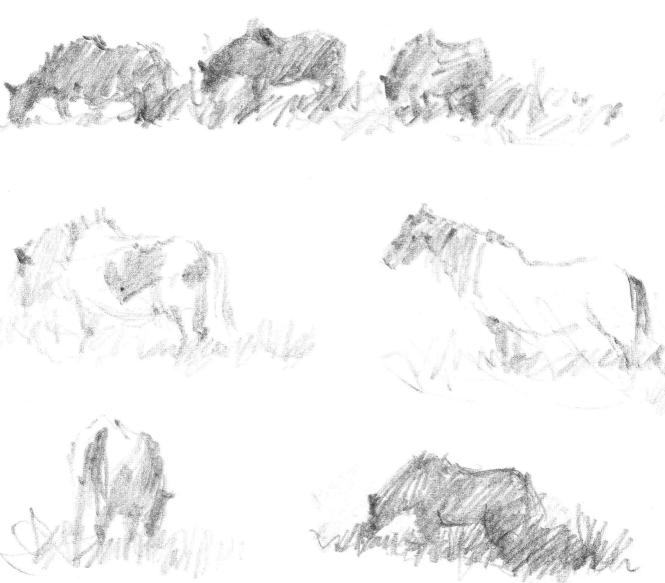

done on such a day, and so were June's pencil sketches, *left*. Notice how the pencil has been used to shade tone into the sketches, especially in June's.

Whatever type of day out you have, your first essential is *to find a painting spot quickly*. If the day out is for sightseeing and you just intend to do a couple of sketches, then it is imperative that you make quick decisions. You must not look for painting subjects as your top priority of the day; that belongs to sightseeing. When you are enjoying looking around, you will soon find something to inspire you, and it is at this point that you should decide whether to paint or draw it. If the subject is impractical then don't try to do it. And don't be annoyed that you couldn't − or you'll spoil the rest of the day for yourself!

This pencil drawing was done one day when we were on Dartmoor. The sketch was not planned, the ponies were there, and they inspired me to have a go. Notice how I didn't overwork them at all.
Pencil on cartridge, 13 × 18 cm (5 × 7 in)

Let the others have a swim or build sandcastles! This is what June did when she painted this watercolour of children on the rocks in Jersey. If you make use of opportunities, there is always time to do a quick sketch.
Watercolour on cartridge,
13 × 18 cm (5 × 7 in)

Incidentally, if the weather is warm when you're on holiday, try to have a coffee or a meal outside. This is an ideal time for doing a painting, but make sure you find a seat that has a view and where no-one can sit in front of you and block the view. June and I often have debates as to which is the best table – not for eating but as a vantage point for painting! I did the quick sketch, *right*, in 25 minutes from a table in the main square in Siena. The only trouble is, if you're like me, you finish up with a cold cup of coffee – unlike June, who always wisely drinks her coffee first and then starts painting!

The third section in this book deals with one or two week holidays. These, of course, give you plenty of scope for painting. However, if it's a holiday with non-painting friends or family, you will need to be more patient and prepared to compromise. A beach-type holiday is ideal: you'll find plenty of subjects, and this doesn't stop the rest of the party from

enjoying themselves. June's typical beach scene with rocks, *below*, was done in Jersey. This reminds me – do beware of the sand flying into your watercolour paint box as people rush by you if you are on a soft sandy beach. Try to keep it well-protected at all times. June and I have both been in situations where our boxes have become smothered with sand in this way. You can't work with it in your paint because it scratches the paper and leaves lines in your washes. It also takes ages to get rid of and wastes a lot of paint.

Whatever type of holiday you are going on, here are a few more words of warning. If you don't normally have much time to paint at home and your holiday will be the first time you have painted for a few weeks, you *must* get some practice in before you go. You can't expect to go in at the deep end the minute you step out of the car or off the plane. So many people are disappointed with themselves and their holidays

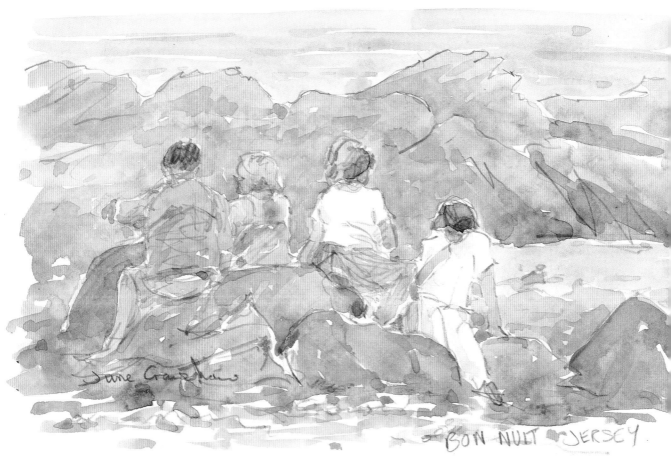

BON NUIT JERSEY.

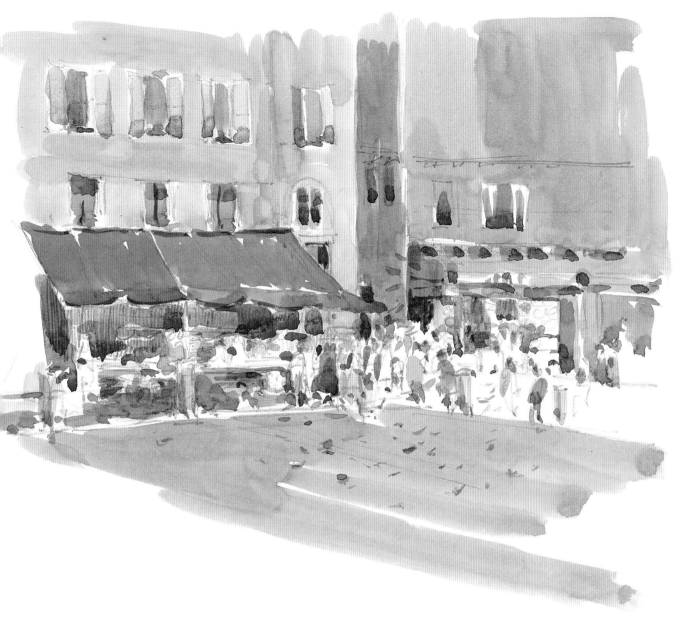

because of insufficient preparation. I know that if I hadn't painted outdoors for a couple of weeks or so, it would take me a day or two to get back into the swing of it again. So my golden rule is: if you are going away to paint, do plan some time in the previous month to go out and sketch a few times in order to get into the mood. If you try to do this, you really will enjoy your holiday much more. After all, you don't want to spend half your holiday getting back into painting again, and not be able to enjoy painting at least some of the holiday scenery at your best.

Something else that is very important is not to rush outside and draw the first scene you see during your first half-hour

on holiday! This doesn't mean you shouldn't take advantage of an opportunity – always do that. But I find that if you take your time during the first day to become familiar with your surroundings, the colours, and the whole environment, your painting will benefit. Naturally, if you are in one place only for a day, you can't indulge in that luxury. Another thing to avoid is burning up all your enthusiasm and inspiration in the first couple of days. Pace yourself and combine your painting with other holiday adventures, but always remember to have your sketchbook and paints with you – you never know when an opportunity is going to arise.

I did this painting from a table outside a café in the main square in Siena. This is a very typical impromptu holiday sketch. There wasn't time to get involved in detail – it was simply an impression of the scene that I was after.

Watercolour on cartridge,
20 × 25 cm (8 × 10 in)

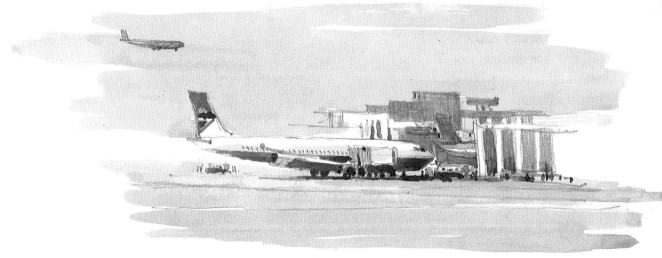

I had been watching aeroplanes for about half an hour before I thought of drawing them. Still, we all have lapses of creative energy!
Pencil on cartridge,
8 × 23 cm (3¹/₂ × 9 in)

BELOW
I missed most of my lunch-break to paint this scene but it was worth it.
Watercolour on cartridge,
20 × 28 cm (8 × 11 in)

On the subject of painting opportunities, when June and I were staying overnight at a hotel overlooking the runway at Heathrow Airport, it suddenly occurred to me while looking out of our window that I was in a perfect spot to draw some aeroplanes. So out came my sketchbook and I drew the two sketches, *above* and *below right*, with my 2B pencil, and then painted over them with very simple watercolour washes. On holiday, this type of situation is always around the corner, so do try to be aware of it.

Another instance was when we were in Provence with students. Everyone was having a picnic lunch, and I saw the scene, *below*. The old car was so out of character with the surroundings that I had to paint it, and therefore I had a very *short* lunch break!

You must also accept the situation that doesn't materialise. The drawing of the two cows, *above right*, was done on one of these occasions. They came into my view, didn't stand still, and moved off in 60 seconds. Still, that time my coffee didn't get cold!

If you are going abroad, you are not allowed to take turpentine for your oil painting on the aeroplane, so you must get it at your destination. You will find in most countries that it's easily bought from art shops, ironmongers or general stores. If you find that having to pack a folding

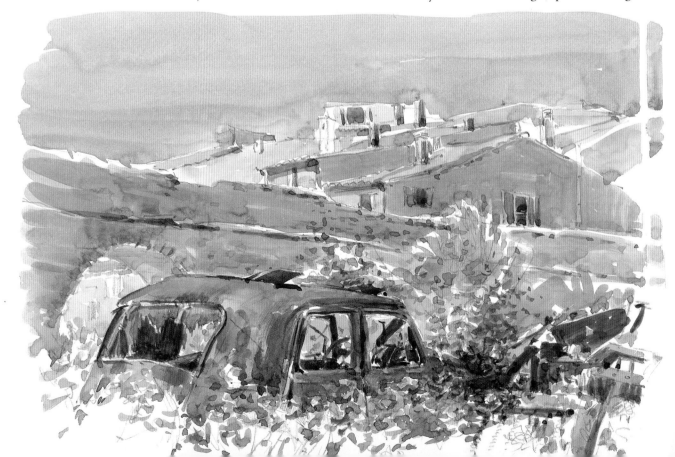

chair makes your luggage difficult to handle, don't take it. You can usually buy a cheap but reliable one abroad from a local supermarket. If you can't find a chair, there's usually something around to sit on for working.

If you take tubes of paint in your hand luggage, as I do, be prepared for your bag to be searched at airports. On one of many occasions that my painting bag was searched, the official explained that on the x-ray machine the tubes of watercolours lying side by side in a box looked suspiciously like a row of bullets!

If you take an easel abroad and you haven't a carrying case for it, make sure you strap all the legs together, as during transit they can come loose and get bent or broken. Wherever you go, especially abroad, take all your materials with you. It may take all week to find an art shop and then they may not have the colour you want or your brand. This can be disastrous, so make sure you are a self-contained painting unit for holidays.

The final type of holiday I describe in this book is a painting holiday with other students and a tutor. Nowadays, this is a vast selection of painting holidays available, ranging from weekends in Britain at residential centres to one-week or two-week holidays abroad in a variety of locations with an accompanying professional painter/tutor. There are naturally many factors to be taken into account when choosing such a holiday: who the course tutor is, whether he or she paints the way you would like to paint, which painting medium you can work in, and, of course, the location and the price. The specialist art and painting magazines are the best places to look for

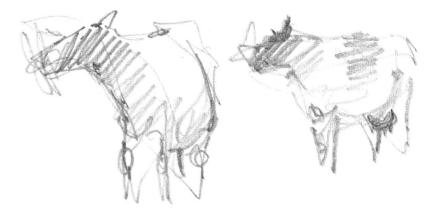

details of such holidays. The most important function that June and I have when we take students on our courses is to mould everyone together into a happy team, irrespective of painting ability. So, for those students who are concerned about painting in front of fellow artists (and I do accept it as a real fear), remember that the rest of the group are on your side and that half of them probably feel exactly as you do. You have had the courage to embark on a course, knowing how you feel, so I am sure that you will have the courage to paint in front of other students.

If you are with a group travelling abroad, may I suggest that you make your luggage as light as possible? When we went to the Greek island of Hydra, we had to travel to the airport, go through customs when we landed, board a coach, embark on a hydrofoil, disembark, and *then* get to the hotel. Naturally, you can get help from fellow students, the coach driver and the courier, but there is a lot of baggage handling which is your responsibility. And remember your tutor. My arms were nearly dropping off after helping students on our Greek trip! On page 128 there is a holiday checklist and I hope you will find this useful if you are planning to go away. You can adapt it for any type of painting holiday.

ABOVE
I saw these cows for only 60 seconds and they wouldn't keep still, so I gave up. The subject that moves away is all part of painting outdoors, so don't get irritable or cross – it doesn't help. Just look for another subject.
Pencil on cartridge,
5 × 10 cm (2 × 4 in)

BELOW (LEFT)
Remember that you don't need to work large. This sketch was done the size it is reproduced here.
Watercolour on cartridge,
4 × 10 cm (1³/₄ × 4 in)

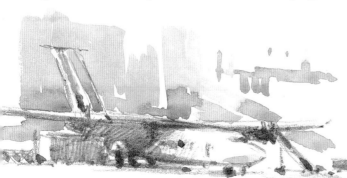

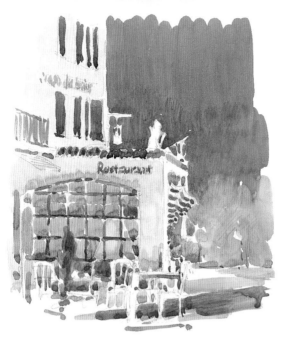

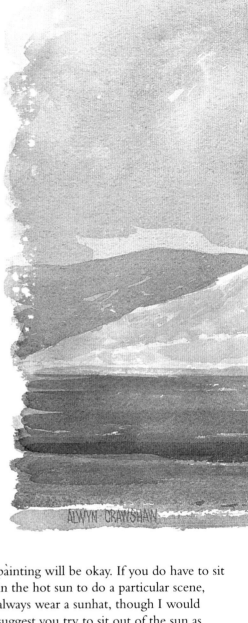

ALWYN CRAWSHAW

This was done outside in poor light when the tonal values looked much darker. When I saw it later in good light, I wished I had made the sky and the hotel walls darker because it would have given a better illusion of night-time.

Watercolour on cartridge, 25 × 20 cm (10 × 8 in)

Whichever painting holiday you choose, accept the fact that you will paint no larger than 25 × 38 cm (10 × 15 in) for watercolour, and 25 × 30 cm (10 × 12 in) for oil. If you take an easel with you for oil painting, then you could go to 40 × 50 cm (16 × 20 in) in size.

The reason for keeping things small is simple. Firstly, if you are painting a large picture, you may not have time to finish it because of holiday circumstances. In fact, you may not even want to *start* it because, being in a relaxed holiday mood, the thought of a large blank canvas could be too daunting – especially one that could take you all day to fill.

Secondly, if you restrict yourself to two or three large paintings, you could miss out on many other views to paint. By working small, the paintings don't take long to do, equipment will be lighter and easier to carry, and far more versatile for painting when an impromptu occasion presents itself. The painting, *above left*, is one I did after having coffee one evening outside our hotel in Provence. I didn't expect to do a painting, especially as it was dark, but then I suddenly thought, 'Why not!'

If you are working in bright sunlight and you find that the paper or canvas is too bright, use your sunglasses. I do, and as long as you keep them on all the time you are painting the same subject, your

painting will be okay. If you do have to sit in the hot sun to do a particular scene, always wear a sunhat, though I would suggest you try to sit out of the sun as much as possible. When painting, you can easily forget about the heat of the sun and the resulting sunburn can make you feel ill for several days. On another note of discomfort, if you're heading for a hot climate, pack some insect cream or, better still, a mosquito coil or a plug-in mosquito repellent for your room.

If the weather is bad, don't give up. You can paint from your bedroom window if you have a view, or from your car, a café window or any obvious shelter

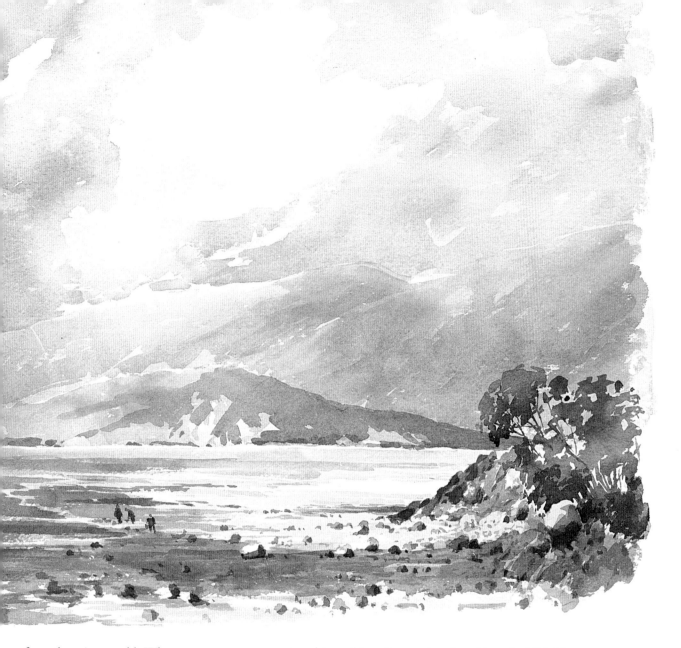

from the rain or cold. When we were on holiday in Scotland, I painted the picture *above*. We weren't near the car, so we made up an 'igloo' with an umbrella and two large plastic bags which I usually carry in my painting bag. I stopped painting on four occasions, scrambling under cover as rain squalls came across the loch. In the painting, there is one just coming over on the left. I never found out exactly what the three people were doing on the beach in the foreground of the painting!

If you are in a rainy or wintery climate, carry your sketchbook in a polythene bag in case you drop it. If it fell in mud or water, this could spoil some irreplaceable painting memories. It's also a good idea to take your camera with you and photograph your painting spot. Then, if you want to paint a larger picture from your sketch when you are back at home, you have a photo to help you with features you may not understand on your sketch. Also, take photographs to use as starting points for work you do at home. I have written a section which begins on page 98 about working at home from holiday sketches and photographs. This is a wonderful way of finding painting inspiration and capturing holiday memories, so do try it!

I did this watercolour in between heavy showers. Try to be patient and you will get there in the end!
Watercolour on Whatman 200 lb Not, 25 × 38 cm (10 × 15 in)

MATERIALS

When deciding which materials and what equipment to take on a painting holiday, your most important consideration should be to pack *as little as possible*, especially if you are travelling by public transport! If you are using your car, then circumstances are different – you can load a car with as much equipment as you can squeeze in, so that it becomes your own travelling art shop! But remember, you will have to leave the car to walk into the fields or town to paint and so it is only your 'base camp'. Whichever way you travel, the equipment you have to carry needs a lot of careful thought.

PENCIL

I use three mediums when I am on holiday: pencil, watercolour and oil. When I am on foot, I always take a pencil, sketchbook and watercolours, or a sketchbook and oils. Naturally, if I am in a coach or car, I have the three mediums with me and choose which to use before leaving the vehicle. Your equipment must always be readily available and easy to carry. Because of this, I frequently use pencil, simply because you only need a sketchbook, an eraser and pencil, which can be carried very easily *(illustrated opposite)*. My watercolour and oil painting equipment is also easy to carry and this is explained on the next pages.

I use a 2B or 3B pencil and carry a kneadable putty eraser for rubbing out. (Incidentally, never worry about rubbing your work out – it's an accepted part of drawing.) I always carry a small penknife to resharpen pencils. Sketchbooks are filled with cartridge drawing paper and come in various sizes. June and I both normally use an A4 size, 20 × 28 cm (8 × 11 in), but June always carries an A5

size, 20 × 14 cm (8 × 5$\frac{1}{2}$ in) in her handbag as well, with a pencil, so she can always do a small sketch at any given time.

One last point: I always find a spiral-bound sketchbook much easier to handle than one bound normally. The pages fold back on themselves, which makes the book very easy to hold in your hand while working.

For sketching on holiday, a spiral-bound sketchbook, a pencil and a putty eraser are all you need and can be carried very easily.

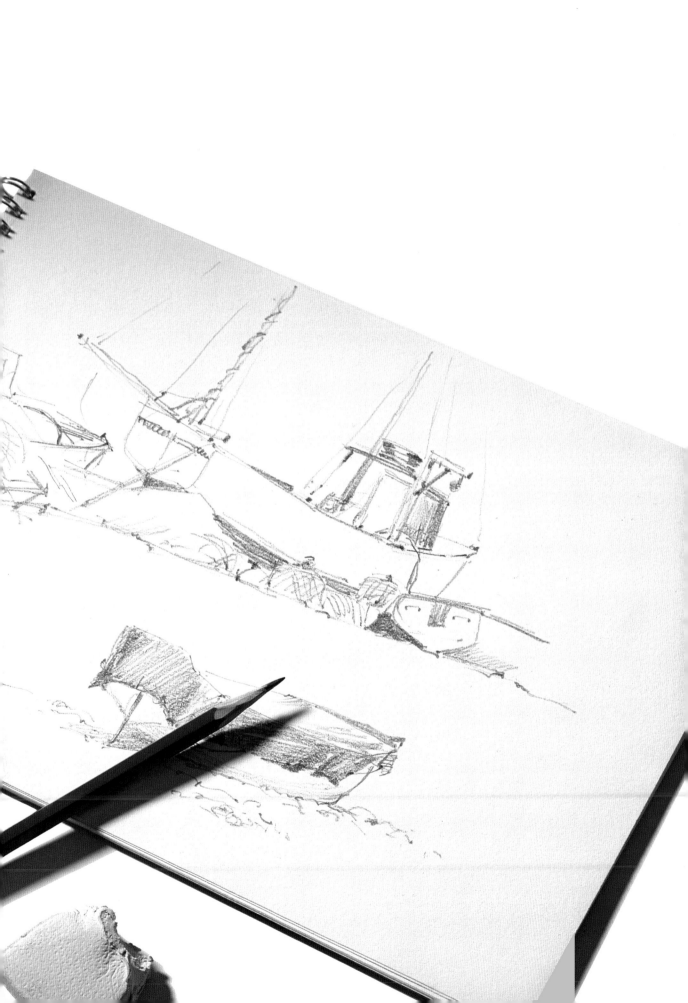

WATERCOLOUR

If you paint in watercolour, you will have your favourite equipment and no doubt will have devised many ways of making it easy to carry. Let me show you the equipment and materials that both June and I use for painting in watercolour on holiday. All the holiday paintings in the book are done with them.

Colours

I always use the same six colours and these are Crimson Alizarin, Yellow Ochre, French Ultramarine, Cadmium Red, Cadmium Yellow Pale and Hooker's Green No. 1.

Brushes

I use three brushes. These are a Daler-Rowney Series 40 No. 10 round sable, a smaller Series 43 No. 6 round sable and finally, for detail work, a Dalon Rigger Series D.99 No. 2. These brushes are the only ones I use, for both large and small paintings.

Paper

For small paintings, I use the cartridge drawing paper in my sketchbooks. For small and large paintings, up to 38 × 50 cm (15 × 20 in), I use Bockingford Watercolour Paper and Whatman Watercolour Paper.

Basic Kit

For the majority of my work up to 28 × 40 cm (11 × 16 in), I use the Travelling Studio, which I designed and which is now on the market. It is shown in the photographs opposite. Both June and I used this in nearly all the programmes for the TV series in Majorca. It is totally self-contained.

The shoulder-strap round your neck supports the kit, the water cup is held firmly on the tray, next to the paint pans, and your left hand supports the pad. You can even stand up and paint with this kit – I never go anywhere without it. The

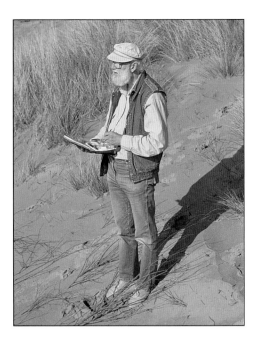

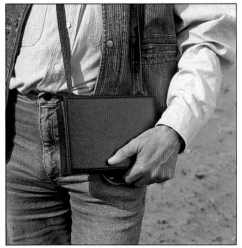

OPPOSITE
The Travelling Studio is totally self-contained. I find it indispensable for holiday work.

ABOVE (RIGHT)
You can even use it standing up.

BELOW (RIGHT)
When it's not in use, everything packs neatly away for carrying.

contents of The Travelling Studio are: six Daler-Rowney Artists' quality Watercolours (my colours) in a removable aluminium paintbox, a sable brush, a Langton Watercolour Book (with Bockingford paper), 13 × 18 cm (5 × 7 in), and a pencil. It has a rustproof water bottle and water cup-holder. All this is neatly held together in a tough PVC waterproof case with carrying-strap and weighs only 500g (1 lb). It's just like carrying a lightweight camera.

To work bigger than the pad in the Travelling Studio, simply rest a larger pad over it and you will find it just as easy to

work with. June and I both use this equipment and these materials for all our holiday painting. However, if we are going on a holiday solely for the purpose of painting, we do take a larger paintbox with more mixing space, and a lightweight board on which to put our 38 × 50 cm (15 × 20 in) size paper, which we rest on our knees to paint.

Remember – the key words for your holiday painting equipment should be – *lightweight and portable!*

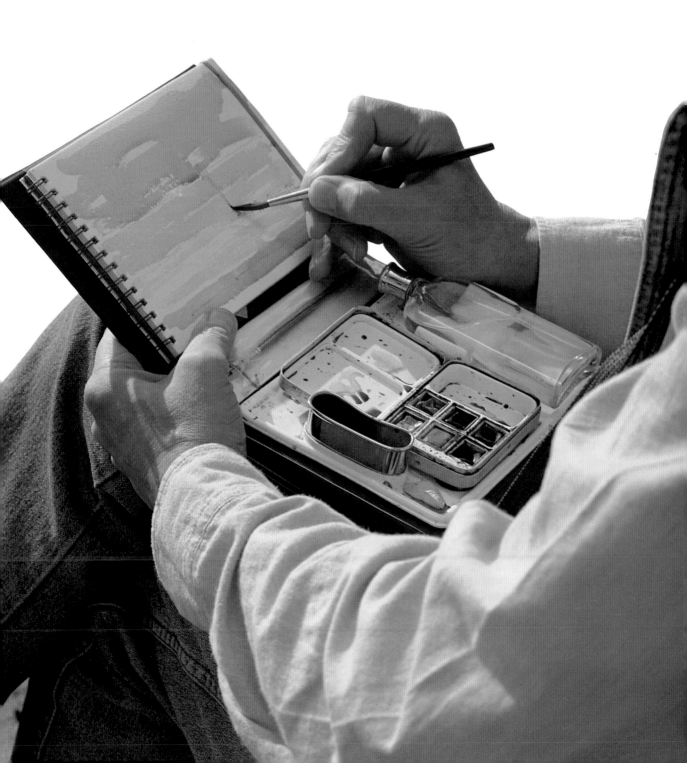

OIL

The same criteria apply to materials and equipment for painting in oils on holiday as they do for painting in watercolour. Obviously, oil painting equipment is heavier and more cumbersome but, don't worry, it can still be made lightweight and portable for holidays.

The golden rule here is to take only what you need and not to take too many 'spares'. Remember, a tube of oil paint is not very heavy on its own but, if you take a few extra tubes along with other spares, you will soon find your equipment getting heavy. If you have more than one tube of the same colour at home, take the smallest tube or the least full with you. It makes a lot of difference to the space and weight, believe me! However, if you are travelling by car, that's a different matter and you can keep as many spares in it as you like!

Basic Kit

There is on the market a carrying box called a 'pochade box', which holds all the materials you need, and which takes a board 25 × 30 cm (10 × 12 in). The board is in the lid, which acts as an easel when you sit down with the box resting on your knees. I use this for much of my painting outside but because I wanted something that I could pick up and put over my shoulder at a moment's notice like the Watercolour Travelling Studio, I designed the Oil Travelling Studio.

This measures 22 × 18 × 8 cm (8^1/$_2$ × 7 × 3^1/$_2$ in) and contains a palette with a single dipper for turpentine (use a *tube* of Gel Medium for driers); five brushes, a pencil, seven tubes of paint, a palette knife, and two ready-primed painting boards, 15 × 20 cm (6 × 8 in). As an alternative, it will take four pieces of *thin* hardboard for painting and these will also fit into the lid. The lid can be kept rigid at four different angles without being held, while you are painting.

When you have finished painting, your

colours can be left on the palette because, when the lid is closed, there is enough space between picture and palette to avoid damaging your painting. With this kit, you can easily stand up to paint because the box holds all your materials. I used it outdoors for all the 15 × 20 cm (6 × 8 in) oil paintings in this book, and the TV series in Majorca.

Colours

I use Daler-Rowney Cobalt Blue, Yellow Ochre, Cadmium Yellow, Crimson Alizarin, Viridian, Cadmium Red and Titanium White.

Brushes

I use Rowney Bristlewhite Series B.48 Nos. 1, 2, 4 and 6, although I have to cut the handles shorter to fit into the Travelling Studio. I also use a Daler-Rowney sable brush Series 43 No. 6 and a Dalon Rigger Series D.99 No. 2.

OPPOSITE
Like the Watercolour Travelling Studio, the Oil Travelling Studio is totally self-contained. It holds everything you need for small oil paintings.

ABOVE RIGHT
It is small enough to be carried over your shoulder comfortably – ideal for holidays.

BELOW RIGHT
This kit is so versatile that, with the strap round your neck, you can even stand up to paint.

Working Surfaces

I work on hardboard that I prime with three coats of Acrylic Primer; ready-prepared Daler Boards, and I prime Whatman Watercolour Paper with three coats of Acrylic Primer. I find the last surface very pleasant to work on, and it is lightweight for carrying. If I work larger than 25 x 30 cm (10 x 12 in), which I wouldn't normally do on holiday, I take my portable easel and stretched canvases, as well as larger boards.

Mediums

I prefer to use Low Odour Thinners instead of turpentine (there is no smell) but as these are not always readily available abroad and because you can't take either Low Odour Thinners or turpentine on planes, I am quite happy to use turpentine on holiday. You should be able to get this from the local ironmonger if you can't find an art shop.

I also use Alkyd Medium, which is in a bottle, or Gel Medium (this comes in a tube) to mix with the paint, which speeds

up the drying time. I carry a small palette knife, for cleaning the palette and scraping areas off the painting if needed. The palette is an integral part of the pochade box and the Oil Travelling Studio.

You only paint small pictures with the Oil Travelling Studio, but it's far more rewarding to go out for the day and come back with two or three small paintings, rather than one large *unfinished* one!

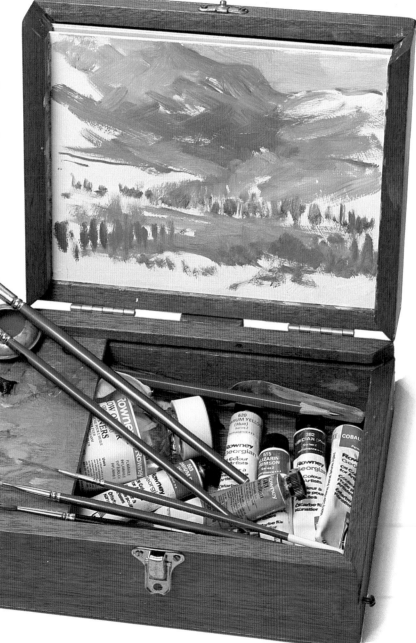

TV PAINTING
HOLIDAY

*A Majorcan adventure – working in front
of the cameras for the six-part television series,*
Crawshaw Paints on Holiday

PAINTING UNDER PRESSURE

This plant was so simple in shape and form that I just couldn't resist drawing it.
Pencil on cartridge,
14 × 4 cm (5¹/₂ × 1¹/₂ in)

When I was asked to make a new series for television, the thought of it really sent the adrenalin surging through my artistic veins! I was certain that the pressure wouldn't be as acute as before, simply because I had gained experience and television 'know-how' while working in front of the camera during the filming of my previous programmes. Then I was informed by the director that, this time, the format was to be quite different – so it was in at the deep end again!

Naturally, the experience gained on my first series, *A Brush With Art*, was invaluable, but I had much exciting new ground to tread in the weeks that followed. The new series, entitled *Crawshaw Paints On Holiday*, speaks for itself and this is why I have included it in this book. I hope that the following pages (which also let you in on some of the behind-the-scenes stories) will entertain as well as inform you, and give a little insight about what went into the making of this television series about a couple on a painting holiday.

The first big difference, therefore, was that I wasn't working alone in this television series. If I went on holiday, naturally June would accompany me, and since June is an artist she would paint as well. Also, because we were 'on holiday' in the film, we would have to be seen walking around, enjoying the surroundings – a very simple form of acting, but by no means as *easy* as it sounds!

Although the programmes have plenty of painting instruction in them, this is not all concentrated into one picture per programme, as was the case in my previous series. This new format entailed doing four or five paintings between us for each programme and consequently a great many different locations had to be found. Also, each of these paintings had to be *finished* – often under camera – even if in the editing of the programmes they were shown incomplete, or not shown at all!

Finally, the series was filmed in Majorca, so June and I were not on 'home-painting' ground. We were promised warm to hot weather with very little rain, if any, and our base would be a villa in the mountain village of Deyá on the north-west of the island – an extremely beautiful area with endless painting possibilities.

From the outset, one thing was very clear – this was not going to be a relaxing holiday! Upon arrival, we spent the first ten days rushing around the island, looking for suitable locations with David Hare, our producer, and Ingrid Duffell, our director. We searched from early morning to dusk each day, needing to find approximately forty perfect painting spots. The problem with this very important aspect of the filming was that every scene June or I chose for a painting had to please the director and the producer, artistically and technically. Questions filled the air. *Is it pretty enough? Does it tell a visual story? Is there room for the camera to be positioned behind the artist to film the painting being done? What will it look like in morning, as opposed to afternoon light? Is there a good view from the other camera – the one to which the artist talks while painting?*

Each time you find a scene to paint that satisfies everyone (and at times you think you *never* will) it brings a wonderful feeling of achievement! When we had all finally agreed on the very last location, it was possible for the filming schedule to be worked out. This included a day on location at Valldemosa, where Chopin once stayed and worked, and two days' filming in the capital, Palma. The

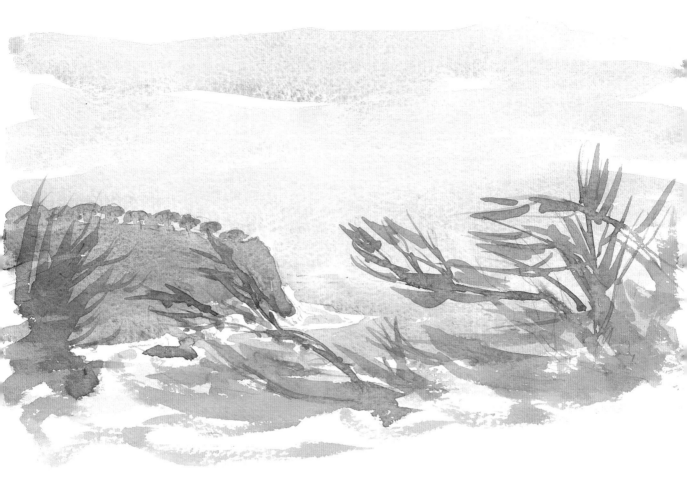

programme we planned to take place in the cathedral town of Sóller was finely timed, with June and I arriving there by train from Palma. Many factors had to be worked into the schedule – the scene in the orange grove needed to be filmed on a certain day agreed by the owner, and so on. When the schedule was finally drawn up, it appeared to me more complicated than the one for *Ben Hur* must have looked! The next twelve days were definitely going to be hectic...

In an article about the filming of the series, the Majorcan newspaper reported the arrival of the rest of the film crew from England. June and I were to meet them on location the next morning, to start filming. That night we went to bed feeling mentally prepared, having checked and re-checked our equipment. Have you ever been awakened in the night and lain there, wondering what had made you

wake up? Well, that night I did, and it took me a full minute to realise that it was the sound of heavy, wind-lashed rain beating against the villa. Minutes later, the whole room was lit by a flash of lightening, followed by a tremendous crash of thunder! That storm went on for the rest of the night, and the whole of the next day.

Apart from the tremendous anticlimax for all of us at not being able to start filming, David had to begin re-scheduling 'Ben Hur'! During our next twelve days in Majorca, we had another full day and three part-days of rain and the filming schedule had to be re-organised and re-planned daily. In the end, we lost two whole programmes and had to write two others to suit the weather conditions and our final schedule. However, the end result was still six fabulous, colourful half-hour television programmes.

On our first day, with the wind and rain lashing the villa, June kept her spirits up by painting this scene from our window.
Watercolour on Bockingford, 20 × 28 cm (8 × 11 in)

PROGRAMME ONE

THE VILLAGE

My very first sketch on our working holiday turned out to be a pencil one of some buildings in Deyá, *below right*. First sketches are always very important, providing a good chance to loosen up your mind to painting and increase your powers of observation. As your hand becomes more sensitive to the brush or pencil, your mind slips into a painting mood. And, since success breeds success, if your first sketch of the day is good, this usually sets the standard for the rest of the day! So it is important to take time with it, thinking about your subject and observing it carefully *before* you start work. Notice how I shaded only the darkest areas and left out the middle tones. This kept my sketch from looking fussy and helped to give an impression of light.

The inspiration for the painting, *above right*, that I did in the village of Fornalutx, lay in the steps leading up to the dark area between the houses. I drew first with a 2B pencil on Bockingford paper, and then started to paint the houses from the left-hand side. I used Yellow Ochre with a touch of Crimson Alizarin and, in some places, a little touch of French Ultramarine.

The stone wall on the left was painted with the same colours. The suggestion of leaves on the left is important – I kept them very free and not a solid mass, as they were in reality. Had I made them solid, the result would have been too powerful for the dark area in between the houses. The same applies to the plant on the right-hand wall.

When I had finished the painting, I was pleased with it, no doubt because it was the first painting I had done under camera for seven months, and I was glad to have completed it! Looking at it now, I feel I could have made the left-hand stone wall a little darker. It would have helped to give the picture slightly more dimension.

We all moved down to the bottom of the steps and into the small village square, which was full of barking dogs! I had decided to draw the fountain in the middle of the square, *left*, so I sat down on the steps and began the drawing on cartridge paper, using a 2B pencil. I started at the top, where the wrought-iron lamp is fastened, and worked downwards. When I came to draw in the lamp, I was at the very top of the sketchbook – not good planning, Alwyn! I quietly reprimanded myself and finished the drawing. It went well and, apart from the lamp, I was very pleased with it, so I decided to paint it.

The only decision I had to make concerning the painting was whether to colour the water 'brown', as it looked from my sitting position, or to paint it blue which visually would tell the onlooker that it really *was* water. I decided to paint it blue, and was very happy with the finished result.

One word of warning! If a painting is going well and you start to get excited about it – and so you should – keep that energy inside you until you have finished the painting. That natural positive energy will keep the painting going well. If you release it before you are finished, your painting could suffer.

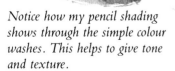

Notice how my pencil shading shows through the simple colour washes. This helps to give tone and texture.

Watercolour on cartridge,
28 × 20 cm (11 × 8 in)

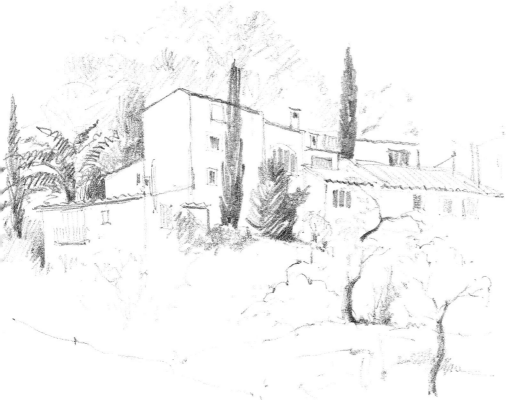

The steps lead you into the painting and up to the dark area between the buildings. Notice how I drew the steps irregularly and how worn they look – this is important.
Watercolour on Bockingford,
20 × 28 cm (8 × 11 in)

My first drawing of the series – I was pleased when I had finished this one. I then started to relax!

Pencil on cartridge,
20 × 28 cm (8 × 11 in)

Ingrid suggested that I should relax while June took a turn in front of the camera, painting an archway. My 'relaxing time' turned out to be a mere five minutes! Very soon, I was being filmed drawing the broken window, *below right*, and the plant in a pot shown on page 26.

When June returned with her painting of the archway, she started to give excuses for what she had done, saying: "I wish I had done this...", "I should have started higher up the paper..." We are all guilty of being negative with our own work when we show it to other people and professionals are no exception! I liked June's painting, *below*, a lot, and felt it had more life and movement than my painting of the building. So June was reassured – and I was put on my mettle!

And so to the last painting of this programme, *above right*. When I first saw

this church, it was in strong sunlight, with shadows helping to give shape and form to the mountain in the background and the olive grove in the foreground. Now, the weather was dull and overcast! Fortunately, the warm, light colours of the church showed up well against the dark background of the mountain.

I worked on primed hardboard with an acrylic wash of Raw Sienna painted over, drawing in with a No. 6 sable brush using a turpsy mix of Cobalt and Crimson Alizarin. Then I painted in the mountains. As I reached the church, I added more Cobalt and White to the mix, to give an impression of distance. The church roof was next: I used Cadmium Red, Cadium Yellow and White. I then worked on the walls, using Yellow Ochre, a touch of Crimson Alizarin and a little Cobalt and White.

At this point the sun came through the mist, giving a soft light over the scene. This lovely effect only lasted for a few minutes, but it gave me information about light and shade which helped to show the shapes and form. I didn't paint over the walls where the main trees were to be painted. This meant I wouldn't be painting the trees over wet paint. I then painted the trees on top of the wall and those in front of the church, and carried on down the painting, working on the olive grove. Notice how I left the Raw Sienna showing underneath in places in the olive grove. This helps to unify the area and gives an impression of sunlight. The dark cypress trees were painted using Cobalt and a little Crimson Alizarin, and only a touch of Yellow Ochre.

Before I finished the painting, the mist turned into rain and the last ten minutes of the painting were done with David holding an umbrella over me while I completed the picture! Even if the weather did let me down on this painting, I was very happy with it and it was a satisfying feeling to have really started work at last...

Notice how June has used steps to help this composition. She worked under camera, painting this archway.
Watercolour on cartridge,
28 × 20 cm (11 × 8 in)

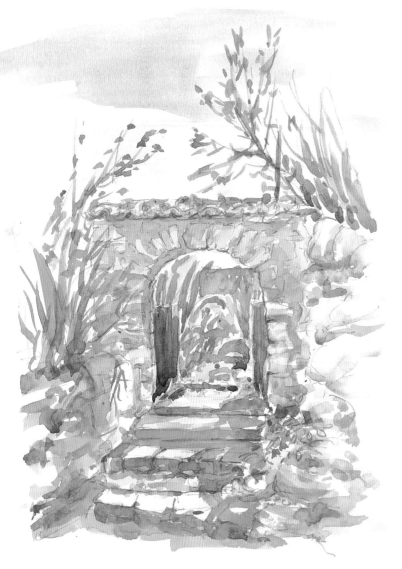

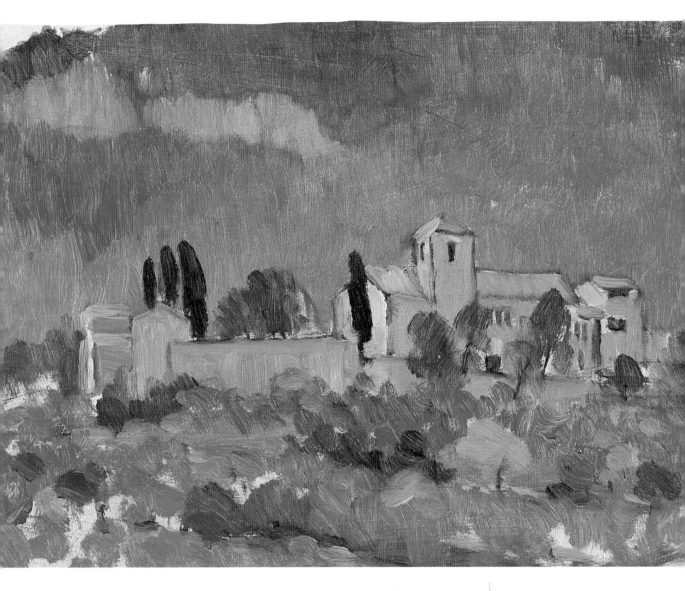

PROGRAMME TWO

THE ORANGE GROVE

If you have ever visited an orange grove, you will know how exquisite the perfume from the blossom is. By now the weather had changed and the temperature was over 27°C, so the warmth of the sun, the fragrance of the blossom and the sheer beauty of the place made it seem like paradise. However, even in paradise, I had to work!

I started with my drawing, *below*, of three rather odd-looking trees, describing them on TV as a Christmas tree, a lollipop tree, and an even funnier one in the middle! Normally, I wouldn't have given these trees a second thought, but Ingrid had asked me if I would draw them and I am very pleased that I did. Standing close together as they do, they make a truly unique study. I used a 2B pencil on cartridge paper and on television I'm shown working in fast motion, giving a fascinating insight, within seconds, into how I did the drawing.

Next it was June's turn. Ingrid had suggested that she should paint the palm tree with poppies around its base which looked like a huge pineapple, *above right*. When she was eventually wired up for

sound and everyone was ready, June looked into the camera and started by saying, "I'm going to paint this pineapple tree..."! This was the first painting that June had done while talking to the camera, so naturally she was nervous.

On the second take, June got into her stride and settled down, talking to the camera and painting her 'pineapple tree' as it became known from then on. She was so engrossed in the painting that at one point, with another slip of the tongue, she called the poppies 'poppy trees'! After she had finished, she told me she now knew what I had been through on previous TV programmes!

Well, the painting turned out beautifully and, nervous or not, June imparted a considerable amount of valuable information while doing it. She used a 2B pencil on Bockingford paper, then started to paint, first establishing the small archway in the wall to the right of the tree, and then putting some tone on the wall. Next came the grass, and she made sure that the poppy areas were slightly exaggerated to give them prominence. When painting the grass, these areas were left as unpainted paper, because the red for the poppies was to be painted in later.

Then June went on to the palm tree leaves, using Hooker's Green No. 1 with a little Yellow Ochre. The colour was too bright, so she added some Crimson Alizarin. The resulting green was perfect and this is a good colour mix to remember. The poppies were not painted individually but as areas of colour because, when you look at such a scene, the image you see is areas of red, not individual dots of colour. Of course, if there are poppies very *close* to you, these will look more like individual flowers.

The three odd-looking trees that Ingrid asked me to draw.

Pencil on cartridge, 20 × 28 cm (8 × 11 in)

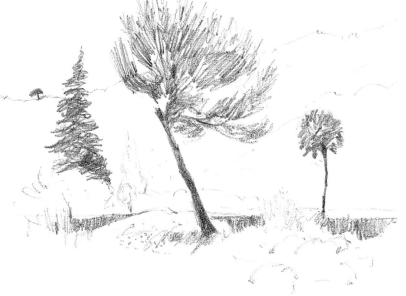

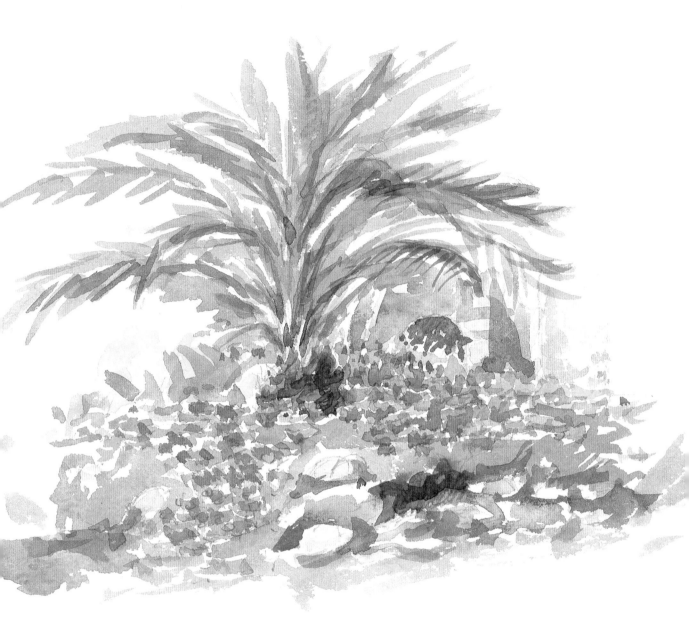

ABOVE
June's palm tree and poppies, which was
soon to be dubbed 'June's pineapple tree'!
Watercolour on Bockingford, 20 × 28 cm (8 × 11 in)

BELOW
June working in the orange grove.

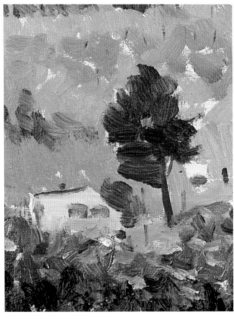

ABOVE
This painting took me over an hour, working under camera, and it was only on the screen for five seconds!
Oil on primed hardboard, 25 × 30 cm (10 × 12 in)

BELOW
The tree had to be painted carefully, as this would help to show distance and scale. This detail is reproduced actual size.

My first painting in the orange grove was a scene looking towards the mountains, with olive groves covering the lower hills, shown *above*. I had decided to do this in oils on primed hardboard with a Raw Sienna Acrylic wash painted over. Although the sun was very strong when looking up at the hills, the colour seemed to be subdued, especially in the olive groves, and the other trees were silhouetted against them, dark but not too contrasting. Running along the bottom of the picture was the bright green of the orange trees.

Feeling inspired, I started at the top and worked down. When I worked the olive trees, I used hardly any tonal contrast between brush strokes, the only real definition coming from the other darker

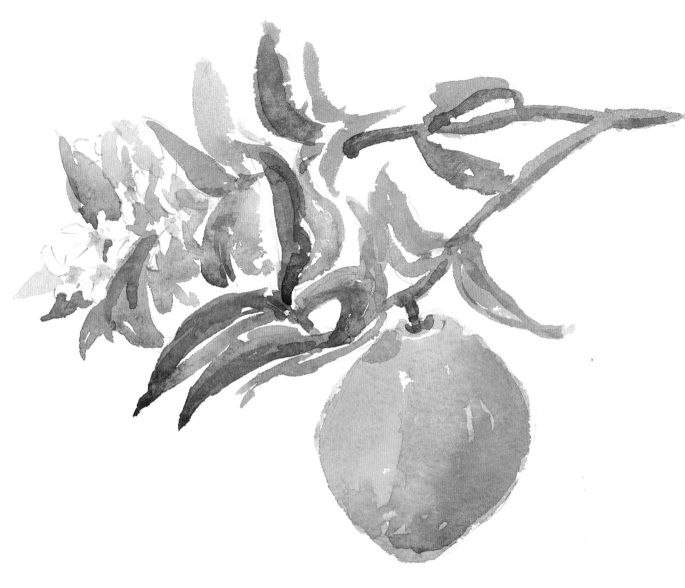

trees on the hills. Notice that, as usual, I have left areas of under-painting on the hills. These are created by 'controlled' happy accident, with each new brush stroke not meeting the last. As in my painting of the church on page 31, this unifies the painting and helps to give the illusion of sunlight. The trees with trunks showing at the top of the painting, and the large one with a trunk at the bottom left of the picture, are very important and had to be painted carefully. This is because they show distance and scale. The close-up, *below left*, shows the actual size of the bottom tree.

June's next assignment was to paint an orange on a tree and it took some time before we found one on a branch in sunlight that could be seen by both June and the cameras. She painted it on Bockingford paper, and drew it in with a 2B pencil. The leaves were painted in next, using Hooker's Green No. 1, a little Yellow Ochre and Crimson Alizarin. The branch was painted in, using the same colour but with a little French Ultramarine added. The white blossom on the leaves was left as white paper and a little tone of warm grey was added in places over the white, to give form.

Then the orange was painted, using a mix of Cadmium Red, Cadium Yellow, a touch of Crimson Alizarin and a touch of French Ultramarine for the shadow areas. The painting turned out really well and the camera got a perfect final shot of June picking the orange off the tree – something she's always wanted to do!

June's painting of the orange. Notice the suggestion of orange blossom on the left of the painting, and the free, unlaboured way the orange has been worked.

Watercolour on Bockingford, 20 × 28 cm (8 × 11 in)

In the last part of the programme, we went to an olive grove to draw olive trees. These are fascinating and I've never seen trees quite like them before. Their shapes are so odd, it's almost as though nature has forgotten to give them a plan for growing. Look at the one June found, *below right*. It looks like a man dancing with a tree! And I don't know what had happened to the tree that I drew for the cameras, *below*. You could almost imagine that the left-hand and the right-hand of the trunk had a disagreement early in life as to which direction to grow, and so they decided to go their separate ways.

We both drew the trees on cartridge paper, using a 2B pencil as usual. It is interesting to see how June's lines are softer and more hesitant than mine, which tend to be heavier and more precise. June often looks at my drawings and comments that she wishes her drawings were as 'positive'. Well, in the same way, I look at June's and wish I had a little more of her freedom. Aren't we all strange? We often envy other artists' work because they have something that we would like to have – that's human nature. But remember that, just because one artist draws differently to you, it doesn't mean that they are any better or any worse than you. Our individual style is the one thing we have

My drawing of the olive tree that didn't know which way to grow!
Pencil on cartridge, 20 × 28 cm (8 × 11 in)

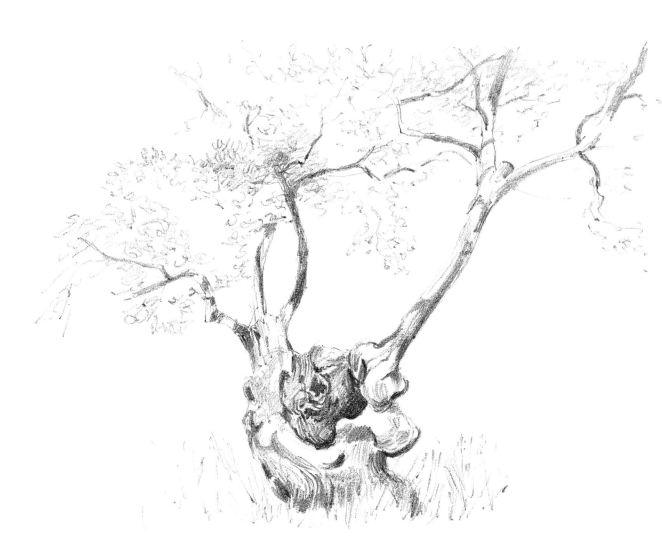

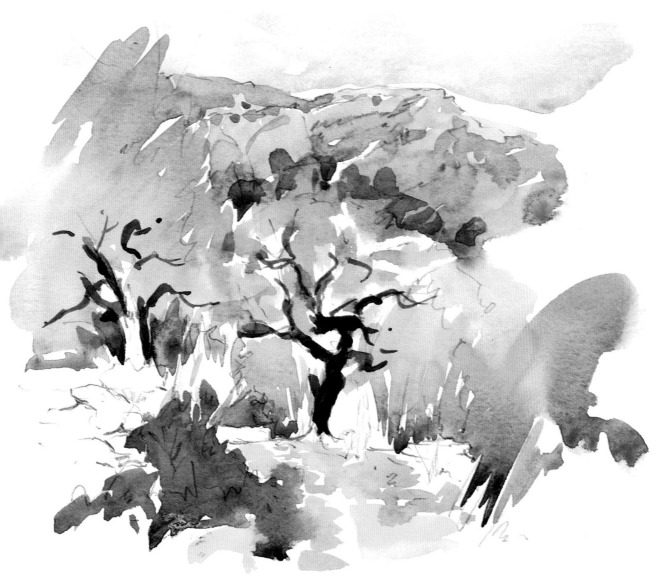

that no-one else can possess, and it is this that makes one artist's work different from another's.

Notice on my drawing how I didn't make the leaves 'solid'. I left plenty of white paper to give the illusion of leaves.

I love June's little watercolour sketch of an olive tree with the mountains in the background, *above*. She did it on cartridge paper and used her No. 6 sable brush only. It's a pity she wasn't filmed doing this one.

This is a little gem that June did of an olive tree. Notice how 'cool' the distant hills are, and how they recede.
Watercolour on cartridge,
14 × 18 cm (5¹/₂ × 7 in)

BELOW
June's dancing olive tree.
Pencil on cartridge,
18 × 18 cm (7 × 7 in)

37

PROGRAMME THREE
THE OLD RAILWAY

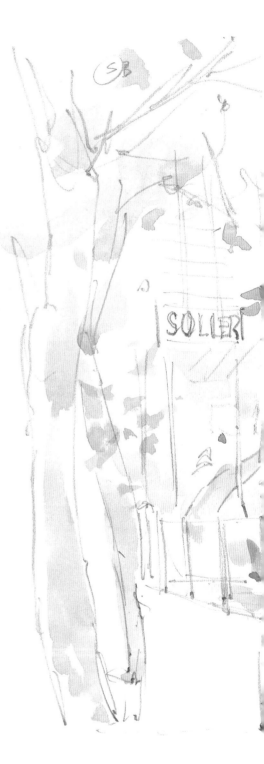

Sóller is a beautiful old cathedral town situated on the north-west coast of Majorca. When June and I were looking for painting spots here, we came to the station and when I saw the scene, *right*, I was tremendously inspired – this was just my kind of subject.

I quickly found a position out of the way and sat down. At least, I *thought* it was out of the way until a tram passed behind me with about three feet to spare, on a line that I had thought was not being used. Moving forward another three feet, I began the sketch on cartridge paper with my 2B pencil, and had just drawn the outline of the front of the train when, with a loud whistle, it went! I was very cross. Still, there was bound to be another one fairly soon.

We waited for half an hour and finally another train pulled into the station. I was ready. I drew the train first, since this was the *movable* object. Then I established the platform and its surroundings. This time the whistle didn't seem as loud, yet still the train moved off and disappeared. But I had done enough – the background wasn't going to move, and there was another train stationary in a siding to give me detail and colour, so I was happy. I put some shading into the drawing, mainly on the train, and then put some delicate washes over the drawing. I didn't paint the sky, deciding that it would have been too heavy for the picture.

Unfortunately, we couldn't paint the train under camera, because of the movement of people and the short time that the train was in the station, so this painting does not appear on screen. This is a pity. Although it's only a sketch, I do feel that it has captured the atmosphere of that lovely old railway station, just as we saw it on that day.

This is one of my favourite paintings of the TV series. I was inspired by the springtime leaves on the tall, elegant trees, the activity of the people, the soft colour of the station buildings and, of course, the old train. To sum it up, I was transfixed by the whole scene!
Watercolour on cartridge, 20 × 28 cm (8 × 11 in)

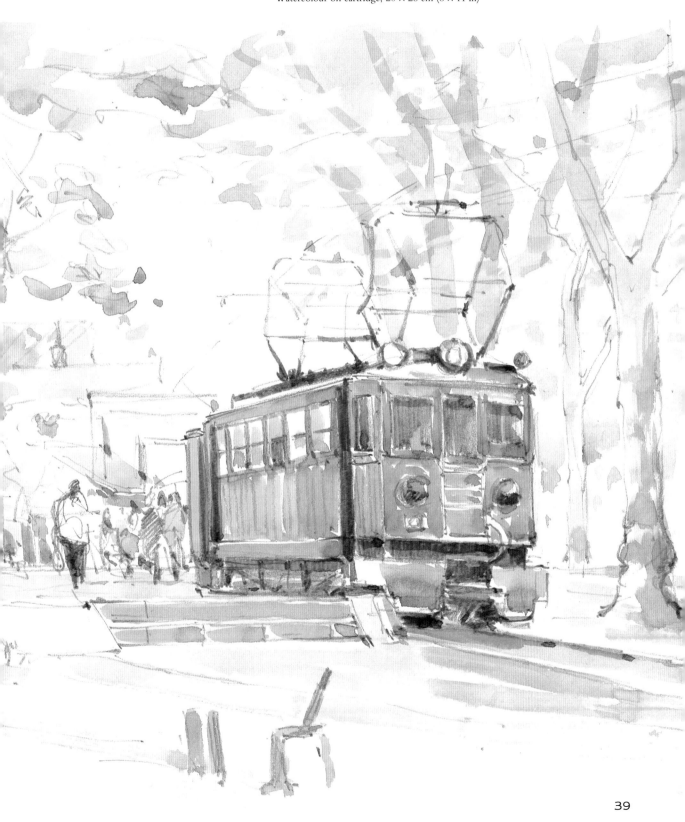

While I was busy painting the train, June had been painting some houses opposite the station, *below left*. She drew it on cartridge paper and then painted it. I like the way the tree in the foreground stands out against the buildings. The dark wash on the left of the tree helps to achieve this. Notice how the small tiled roof on the right of the tree has just been suggested by 'wavy' pencil lines, and the brush strokes painted in the direction of the fall of the tiles. Very simply done, but it achieves its object.

The day of the filming had been organised for me to paint the tram opposite. The Majorcan Tourist Board and railway officials had promised it would be put in a position that was convenient for me to paint, and we were due to start filming at 11 a.m. I then found out what is meant by 'mañana'! After a great deal of talking and waving of official arms, the tram finally was in position at 2 p.m! But the worst was yet to come. We were told that it had to be moved again in an hour – and it can take up to half an hour to get both cameras and sound equipment set up before I can start a painting!

David and Ingrid looked at me and I knew what was coming next. 'You can do it, Alwyn, can't you?'

Looking at the tram, with the sheds behind, trains and trams whistling and moving around me, people coming and going amid the general noise, a camera over my shoulder, one in front to talk to, and the rest of the team watching me, I knew I wasn't going to be the most relaxed artist in the world. Nevertheless, gathering my wits about me, I started.

I worked on cartridge paper, knowing that I would have a drawing even if I didn't have time to paint it. The most important aspect of the drawing was to establish the correct proportions of the front of the tram. If you look at it, it has three horizontal sections and three vertical sections, creating nine separate rectangles. Once I had drawn these on the sketch

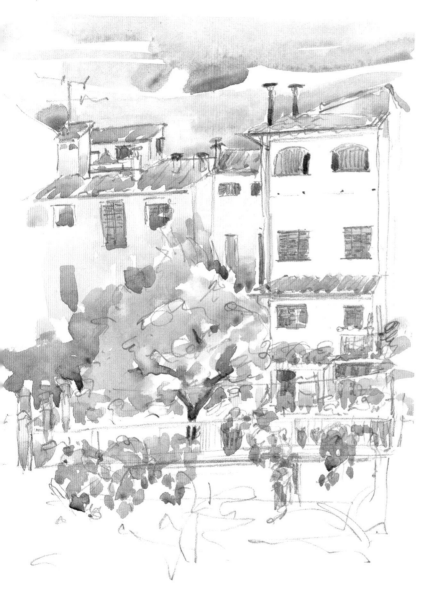

While I was painting the train on page 39, June was looking the other way and painted this little watercolour. What a perfect reminder of a holiday it makes. Remember, don't always rely on your camera for trips down memory lane!

Watercolour on cartridge, 15 × 20 cm (6 × 8 in)

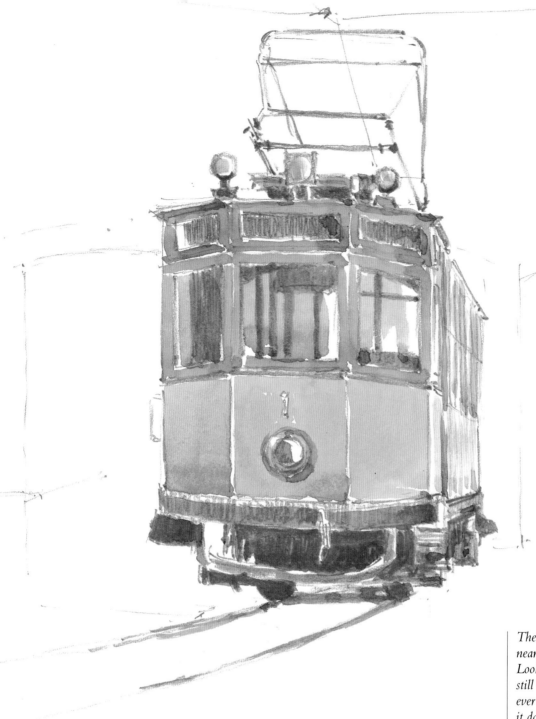

The tram that nearly got away! Looking at it now, I still wonder how we ever managed to get it done, given the circumstances. You need to be confident with your drawing to tackle a subject like this.

Watercolour on cartridge, 20 × 20 cm (8 × 8 in)

pad, the hardest part would be done, so I took my time to get it right. After this, the rest of the drawing was relatively easy. Once I'd shaded in the dark areas, the drawing was complete in its own right. At this stage we could have finished, but there were still eleven minutes to go, and so I quickly got out my paints and put simple colour washes over the drawing. I won't forget that tram in a hurry – the paint was still drying as it was moved away!

LEFT
This was really under pressure!

After we had finished the tram shooting, our next stop was the village square. June and I were to paint the view while sitting at a restaurant table in the open air. This time we were to paint the *same* scene, although from slightly different angles. It's very interesting to note that June saw the view as an upright painting, while I saw it as a horizontal format. I am always intrigued by the way in which different artists can see the same subject in a different way!

June's painting of the square.
Watercolour on cartridge,
20 × 15 cm (8 × 6 in)

The pencil shape on the left of my painting, *right*, is a tree that was in the square. I felt that it added an unusual composition to the picture, and originally intended to paint it as a dark silhouette — the way it looked in reality. I left it to the end to decide, because if I had painted it dark at the start, I would have had to keep it that way, even if I didn't like it. As it turned out, I changed my mind. I left it unpainted, and I think it works. June didn't even think of putting the tree in her painting, and naturally it is perfectly

all right without it. Another difference is that I gave more prominence to the people than June did.

One aspect of both paintings that is very much the same is the colour – except for one area just above the top windows. My wall colour is a yellow, June's is a reddy-orange. I can only think that the wall changed colour above the windows and I didn't spot it!

It was a long day, filming in Sóller. We returned to the villa late but elated, with some good paintings to show for it.

My painting of the square. Painting this complicated scene was a real challenge, with June and me sitting at a restaurant table in the middle of the square, surrounded by activity. Mopeds, cars, people, cats and dogs moved around us continually, and it was all done under camera. Who said painting was relaxing!

Watercolour on cartridge, 20 × 28 cm (8 × 11 in)

PROGRAMME FOUR
WORKING IN THE VILLA

On the eighth day of shooting, we got up at seven in the morning to see the wind blowing the rain almost horizontally across the terrace of the villa. Bad weather was with us again! But this time we couldn't simply stand by and wait for the next fine day because we were running out of filming time. So we put 'Plan B' into action – we would do Programme Four indoors.

The next two hours were spent re-arranging the villa to give the cameras and crew – and, of course, June and myself – room to work. When we were in Sóller Port seeking locations, I sketched the view in biro on the back of a postcard, see page 47. A biro is pretty good for sketching: if you put pressure on you usually get a heavier and thicker line, and if you relax the pressure, the line becomes thinner and paler. This gives you scope for adding tonal values. I now decided that I would use this sketch for working from indoors. I had also done some pencil sketches and taken some polaroid photographs of cactus plants, palm trees and various other subjects, just in case we had to work inside.

So all this work hadn't been in vain! Working over a pencil sketch I had done, I painted the scene, *above right*. I had written colour notes on a separate piece of paper. When I first did the sketch, I had been inspired by the warm colour of the stone wall and the dark shadows behind the balustrade. Notice how simply I have worked the small trees on the left and the large tree, top right. This painting is a good example of light against dark. The balustrade pillars on the left are dark

BELOW
June's pedestal and pot, taken from a photo. There is nothing overlooked in this painting, it is free and simple in approach. Notice how she has used light against dark to help show form and shape.
Watercolour on Bockingford, 20 × 28 cm (8 × 11 in)

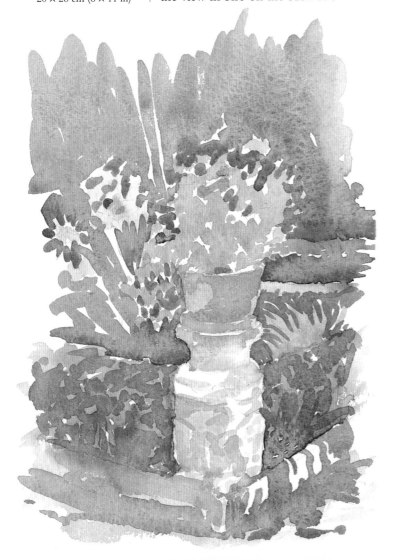

ABOVE
June did this little pencil and watercolour sketch from a photo, too. She kept it simple by leaving out the background.
Watercolour on cartridge, 10 × 12 cm (4 × 4¹/₂ in)

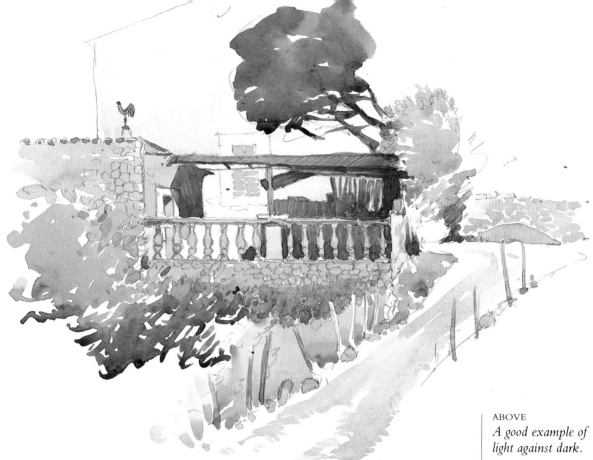

ABOVE
*A good example of
light against dark.*
Watercolour on
cartridge,
20 × 28 cm (8 × 11 in)

BELOW
*This subject was not
my favourite, but I
did it for the
programme.*
Watercolour on
Bockingford,
20 × 28 cm (8 × 11 in)

against the white paper background, while the pillars on the right are light against the dark background. The trees are dark against light, and the foreground grass is first of all dark against the white paper, and then light against the dark wall. Remember that *dark against light* and *light against dark* show the shape and form of objects. Working from a pencil sketch and written colour notes is also a very good exercise. It makes you practise observation, keeps your memory keen, and also allows you to use your imagination.

For the windmill, *right*, I worked from a pencil sketch. I was never happy doing this windmill, but David wanted me to because this type of windmill is very traditional on the island. Naturally, I painted it but to me the composition isn't good and the windmill is too central for my liking. Perhaps I should have moved it over to the left of the picture a bit.

While I was painting, June was working from photographs she had taken. The painting, *far left*, is in my opinion a perfect example of copying a photo and yet making it *look* like a painting – in this case a watercolour. It is free and delicate, yet strong enough to show the form of the stone pedestal and pot. This was done on Bockingford paper. June also did, on cartridge paper and for the camera, a very delicate pencil and wash drawing of a cactus plant from a photograph, *left*.

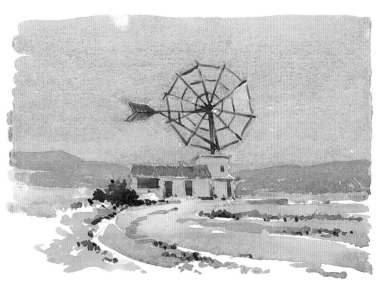

I decided to do the oil painting *below*, of the lighthouse that I had sketched on the postcard, *below right*. I did this on primed hardboard, with a Raw Sienna Acrylic wash painted over. Halfway through the painting, I thought it was going to be a disaster! The subject didn't have enough life in it. We all go through these worrying stages from time to time when we are painting but, after filming half the painting, I must admit I felt a little concerned. And this makes a good point. I am always telling students that if you reach a situation like this, do keep working and eventually you will break through and find that the painting starts to improve, especially in oil.

Well, I sat there working with the cameras turning, telling myself just that. Then, when I began to paint the lighthouse area at the top of the cliff, the painting suddenly came to life, and I felt very pleased and very relieved. The lighthouse area is in a *centre of interest* position on the painting, and the small amount of brushwork gave a feeling of activity which was enough to create interest against the large expanse of 'plain' sky, cliff face and sea that had worried me.

Around 6 p.m. we were finished and the weather had undergone a dramatic change. The rain had stopped and the wind had dropped to a whisper. David loves pictures of sunsets and, as we looked out of the window over the sea, the sun was beginning to set. When I suggested to David that I paint it under camera, he agreed immediately, and so we all had an hour and a half to relax and prepare everything outside, ready for the sunset.

I believe this painting took about twenty minutes. We had to have lights outside for the cameras, and I finished when the sun was a red ball over the horizon. Apart from working fast, the biggest problem was having to look into the sun − the subject − and then back at the painting, which then took on the look of being covered with green and black dots!

Notice how I painted in the headland. I feel it looks a little odd, but it was done to show scale which is very important and I am happy with the result.

ABOVE
Close-up of the lighthouse, reproduced actual size.

BELOW
My finished oil painting from the postcard.
Oil on primed hardboard,
25 × 30 cm (10 × 12 in)

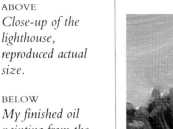

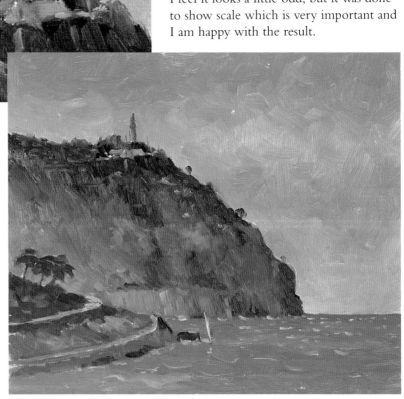

ABOVE
At the end of the day, the rain stopped, the winds dropped, and the sun came out.
And, when it started to set, I was ready to paint it!
Oil on primed hardboard, 15 × 20 cm (6 × 8 in)

BELOW
My biro drawing of the lighthouse, which was done on the back of a postcard.

PROGRAMME FIVE

PALMA

We found it tricky enough at times filming in a small town like Sóller, but Palma was a totally different matter. The roads are wider, the traffic heavier and noisier and the streets are full of milling people in a city, so rushing around to various painting locations is certainly quite a challenge!

We had a scene with June and me in a pony-drawn carriage being driven up an old narrow backstreet to the entrance to the Arab baths. A car was parked in our way (it was a no-parking area) and it took nearly an hour to get the pony and carriage past. The loss of an hour from a tight daily schedule can be devastating but fortunately David was always there, to re-schedule 'Ben Hur'!

I started by drawing the cathedral and the surrounding city from the battlements of Bellver Castle. Because of the vastness of the view, I'd decided that I would only

make a colour sketch, see *opposite*, not a complicated painting. I think it would have taken the whole of the series to do *that*! I drew it on cartridge paper in my A4 size sketchbook, using my 2B pencil. I started with the cathedral. When this was established, I positioned the bottom of the line of hills in the distance, and then the harbour front. Using my pencil, I shaded the cathedral with perpendicular, fluid strokes, which helped to give the illusion of height and a complicated structure.

The colour washes I used were very simple. Starting with the sky, I worked down to the foreground, letting the wet colours blend together. When they were dry, I painted the cathedral dark, then painted in the water, finishing it with single, horizontal brush strokes. Finally, I added some dark accents to the harbour area. Notice how much white paper I left unpainted within the painting. This was

June's painting from the bottom of the castle.
Watercolour on cartridge,
20 × 28 cm (8 × 11 in)

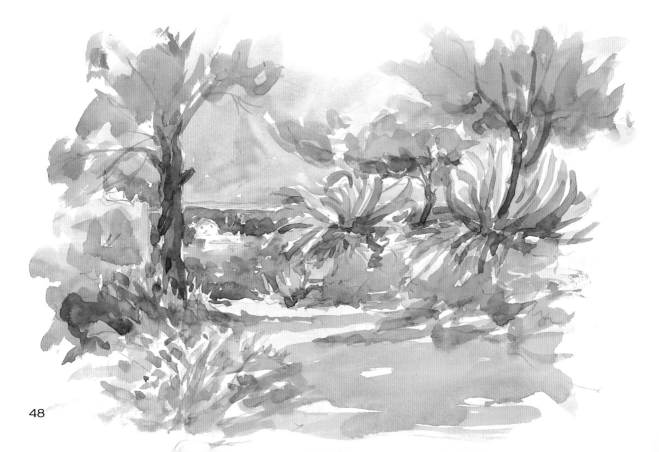

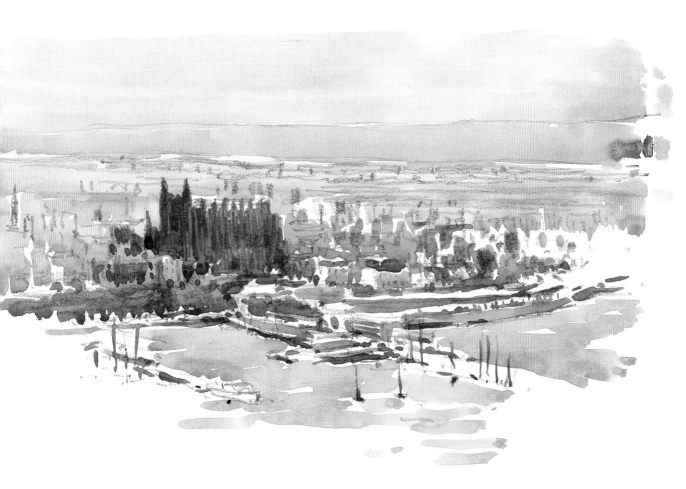

done quite deliberately to help create light and form. Also, by making the cathedral stand out from the rest of the city, and from a very complicated view, I have given the eye something on which to rest. I saw it like this for only a few seconds, as a cloud shadow passed over. But it was enough to register it in my head, because I was observing the scene and making myself familiar with it for ten minutes before I started – a *golden rule* that I always impress on students.

While I was sitting high up on the battlements doing the sketch, June was at the bottom of the castle, painting the view, *left*. I like the freedom with which she has painted the trees and cacti, and the way the scene gives the impression of sunlight. But, above all, I like the strong blue colour she has painted the sea in the distance, which, of course, is what it looked like. By being bold with the subject, she captured the exciting blue of the Mediterranean.

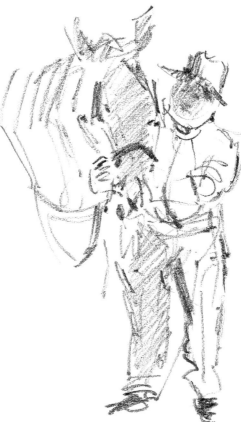

ABOVE
My painting of the cathedral. I wanted to paint this the first time I saw it. I was totally inspired by the vast scene in front of me.
Watercolour on cartridge
20 × 28 cm (8 × 11 in)

BELOW
My quick pencil sketch of Juan, our carriage driver.
Pencil on cartridge
13 × 8 cm (5 × 3 in)

49

ABOVE
In the Arab garden.

BELOW
Notice how I didn't draw all the carriage behind the pony. I just did enough to show that it was harnessed to one.
Watercolour on cartridge,
13 × 19 cm (5 × 7½ in)

It was decided that I would do a sketch of the pony that was taking June and me around the old part of the city. I was a little concerned about the drawing of the front legs, but when you are sketching from life you won't get everything absolutely correct. Like the sky or a sunset, a pony will not remain in the same position for long!

I was very happy with the colour wash I put over the pencil, especially the hind-quarters where the light is casting a mauve sheen on the pony's back.

The Arab baths are in the old part of the city. They are a thousand years old and must have seen many tourists, artists and cameras in their time. From the gardens, I drew the doorway into the baths, *below right*, using my 2B pencil on cartridge paper. The subject made a change from the 'moving' pony and here proportion was very important. I began by drawing the opening, which was a circle on top of a rectangle. When this was established correctly, I could, with reasonable confidence, work outwards on the outside wall, or work inside the doorway. Notice how the pillar inside the doorway becomes thinner at its base. This, we were told, is where over the centuries people have sat on the floor of the baths and leant against it, thus wearing it away. What a story it could tell!

When I had finished the doorway, I had a rest while June sketched a 'normal' doorway with some terracotta pots and plants, *above right*. I think this sketch is one of the best she did. Unfortunately, although filmed, this one is not shown being painted on screen – sadly, it ended up on the cutting room floor!

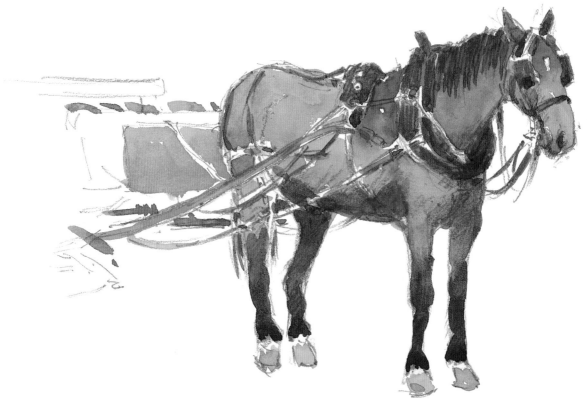

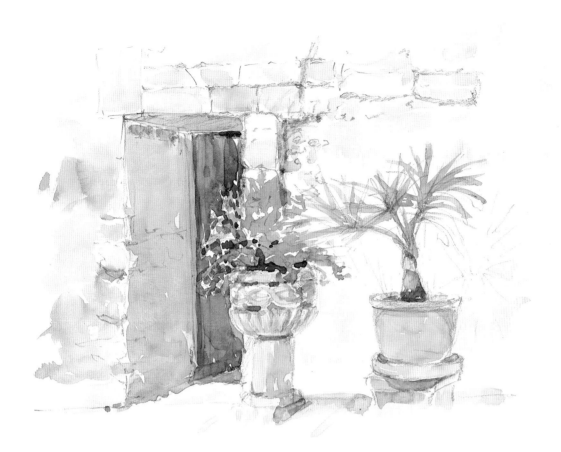

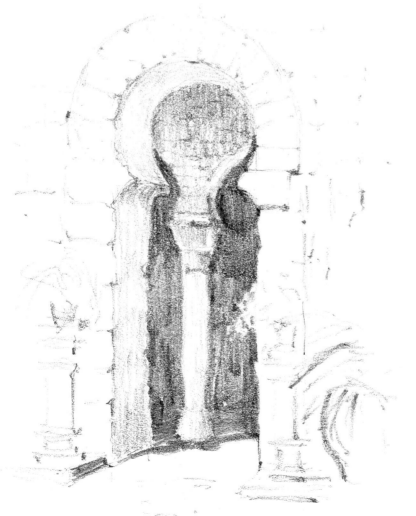

ABOVE
June painted this doorway. The plant and pot on the extreme right of it make a lovely composition.
Watercolour on cartridge,
18 × 25 cm (7 × 10 in)

LEFT
My pencil drawing of a more unusual doorway in the Arab baths. While I was doing it, I couldn't help wondering how many people had gone through it in the last thousand years!
Pencil on cartridge,
20 × 14 cm (8 × 5^{1}/$_{2}$ in)

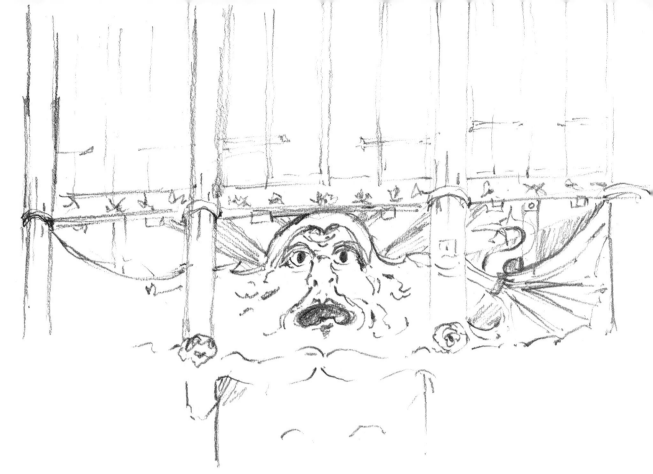

June's drawing of the ornamental carving over the dentist's doorway.
Pencil on cartridge, 12 × 15 cm (4^1/$_2$ × 6 in)

While we were going around the old part of Palma in the pony-drawn carriage, we were shown the old dentist's building. This was tall, narrow and very ornate. The centrepiece of the ornamentation was a large face which stood out in strong relief. However, maybe 'relief' isn't quite the right word to use because, although I don't know whether it was carved from stone, plaster or even wood, the face definitely showed great *pain*! Actually, it was enough to put anybody off going to the dentist for the rest of their lives. Who ever originated the decoration all those years ago must have had a great sense of humour. Nowadays, it is one of Palma's tourist attractions, although I believe a dentist still works there to this day.

June was 'commissioned' by David to do a drawing of the face, *above*, and she was rapidly whisked away with her 2B pencil and sketchbook.

There is also a sequence in the programme where June goes into a traditional baker's shop. Like the dentist's this was very ornate and I had sketched it earlier while we all had a break. Some break it proved for me! My coffee grew cold and I barely had time to swallow my cake in between drawing because of all the twisting and turning I had to do to see the shop front, as numerous people went in and out of it. After all, it is one of the most popular cake shops in Palma! The result is shown on the opposite page and I really wish that I'd had the time to put some colour into it, as it really was quite splendid. But sadly this didn't fit into our programme schedule.

We had two days of filming in Palma for the programme and, on the second day, we were filmed in the evening, walking in front of the cathedral when it was lit up with floodlights – another lovely memory, sadly not shown on TV.

That day we started our journey from Deyá at eight in the morning and returned to our villa at eleven that night. It was the hardest day's filming we had done and, although we enjoyed it immensely, it was with great relief that our heads found our pillows at last!

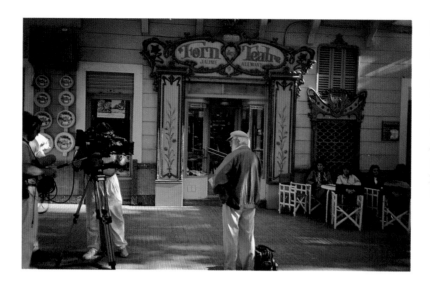

LEFT
The colourful baker's shop.

BELOW
This is the drawing that I did of it, while having my coffee break. They never let me stop!
Pencil on cartridge
19 × 20 cm (7¹/₂ × 8 in)

PROGRAMME SIX
THE HARBOUR

RIGHT

This was one of those paintings that went well from the very start and I was happy with it during all the stages. But, believe me, it doesn't always work that way!

Watercolour on cartridge,
28 × 20 cm (11 × 8 in)

BELOW

June can only remember how quickly she had to do this sketch – at any moment the fisherman could have walked away!

Watercolour on cartridge,
18 × 28 cm (7 × 11 in)

For this programme we went down to the tiny harbour of Deyá. After leaving the vehicles, we had a long walk down a steep, rocky path to the beach – carrying *all* our equipment! By the time we reached the beach, my painting arm was nearly falling off. I have said this many times to students: *only take as much equipment as necessary*. But here I had no option because we had to take all our painting equipment – papers, canvases, boards, oil colours, watercolours and so on, for every day's filming. The reason was that we weren't sure where we might end up, or what medium might be the best for a particular scene.

Anyway, it was a beautiful place and I decided to paint the small fishing boats that the local fishermen kept in huts in the cliff, *right*. It wasn't the usual place you would expect to find a couple of boats. I painted it on cartridge paper in my sketchbook. The most important part of the painting was to make sure that the drawing of the boats was good and the

corrugated roof on the left stood out from the cliff. The pencil lines and brush strokes helped, being worked in the direction of the corrugated shapes. I have left a lot of white paper, not just by happy accident, but to show shape and sunlight, as I did in the cathedral in Palma on page 49. The large dark rock at the bottom of the cliff helps to balance the painting, which proved to be one of my favourites of the series.

We then went to the port of Sóller, a typical Mediterranean harbour with yachts, cruisers, fishing boats and some larger craft for taking tourists out for daytime cruises. Ingrid and David had seen a fisherman mending his nets on the quayside and had suggested that June paint him under camera.

We were told that he would be working for about half an hour but, remembering my experience drawing the tram, that half hour could finish up as ten minutes! June had to work fast in case he went away but she observed his face carefully and his posture, and portrayed these perfectly. When the filming was done, June felt that his right leg (looking at the painting) was too small and thin, but, as the TV filming was complete, she couldn't adjust it. Despite this, we were all pleased with the result, which took about twenty heart-stopping minutes, thinking that he might get up and leave at any time. Actually, he was still there an hour later – but that's life!

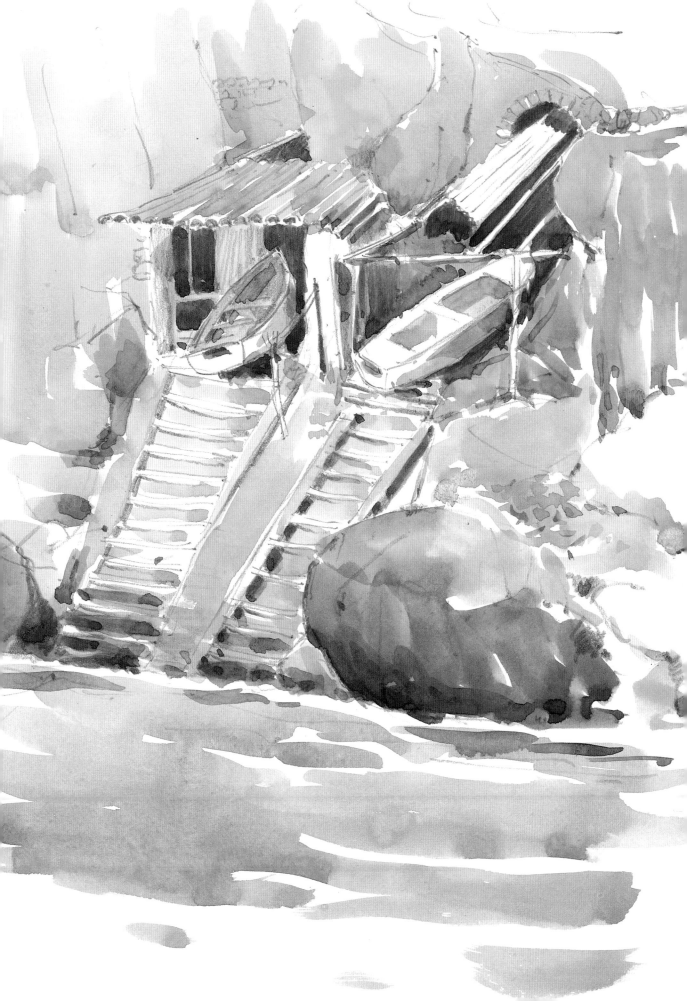

I couldn't get in a position, because of the cameras and crew, to see more of the inside of these boats. From a design point of view, this worried me. At the end of the painting, I was happy with it, but I know I could have got more out of it from a different viewpoint.

Watercolour on cartridge,
20 × 28 cm (8 × 11 in)

The two fishing boats, *below*, were moored in the harbour. There were dozens of boats moored with them and this is one of the big advantages of painting. *You* can decide exactly what you want to paint! So I left out all the other boats but, to add interest, deliberately chose the two with a small stone wall leading to them. I was never really happy with this painting, though. The boats were white but in shadow and, to get the sunlight catching the top of the boats looking brighter than the hull, I had to paint the hulls quite dark. When I looked at the scene with half-closed eyes to get the tonal values, I was correct in painting the two hulls as dark as I did. Even so, I do feel I could have left some white paper somewhere on them, to give a little more

sparkle. It is sometimes very difficult to decide – whether to follow nature, or whether to use your artist's licence. My rule is: *if in doubt, trust nature!*

The last painting in the programme, *right*, was done from the cliffs above the small harbour of Deyá in the evening. I did this on primed cardboard with a Raw Sienna Acrylic wash over. I decided to keep the painting very simple. Most of the shapes were created almost by single brush strokes and I didn't keep overworking them. For instance, look at the rocks and the sea, bottom right, where the brush strokes show very clearly. Although the colours are a little Mediterranean-bright for me (being used to the more sombre colours of the English Channel) I was very pleased with it.

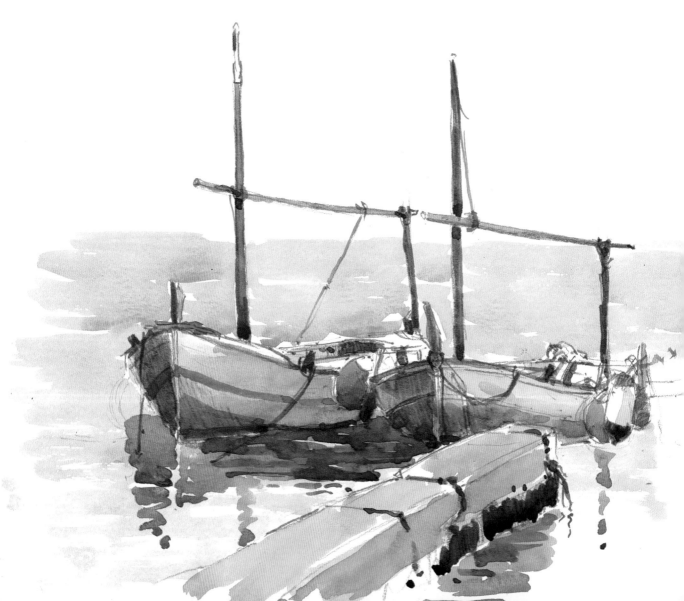

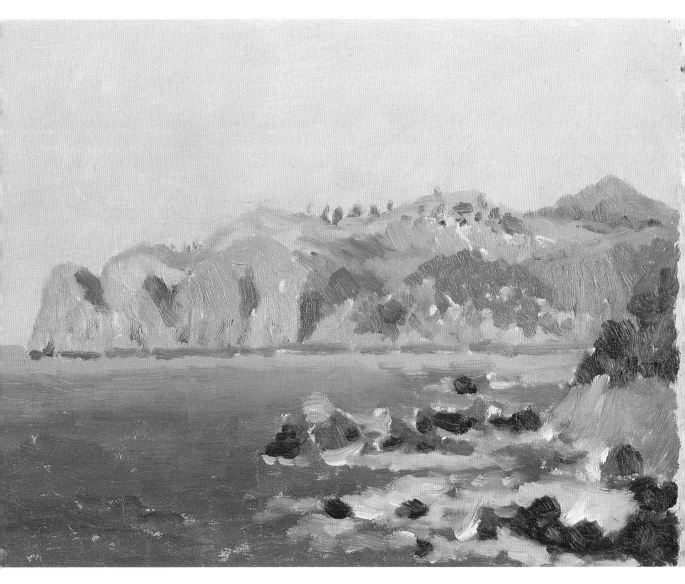

Well, that brought us to the end of our Majorcan filming. Although being filmed on holiday is not something that most of you will experience, I thought it would be interesting for you to see the other side of the camera. Naturally, I could have gone into detail about all sorts of hair-raising experiences, had the book been long enough. Like the time when we were being filmed on the train journey to Sóller, standing outside on the walkway between the carriages, when the wrought iron gate suddenly sprang open! I held onto June, who had been leaning against it, Ingrid held onto me, and the cameraman held on with his feet and a

prayer! At that moment, we entered a long and very cold tunnel and, whilst in total darkness, were soaked by a heavy shower of extremely cold water which must have come from the roof of the tunnel... Of course, we survived to tell the tale. It's a very enjoyable experience, this film-making!

I have painted this type of headland in England but the colours have usually been more muted than they were in Majorca. I found it took a while to get used to working with stronger colours but it did me good, stopping me taking things for granted!
Oil on primed hardboard,
20 × 25 cm (8 × 10 in)

Majorcan Photograph Album
Behind the scenes on our TV painting holiday

If you ignore them, June, they might go away! PALMA

Can I have the next dance, please? OLIVE GROVE

Only the cameraman and I seem interested ORANGE GROVE

One more step backwards, please, Alwyn! DEYA

Will you paint my portrait, please? PALMA

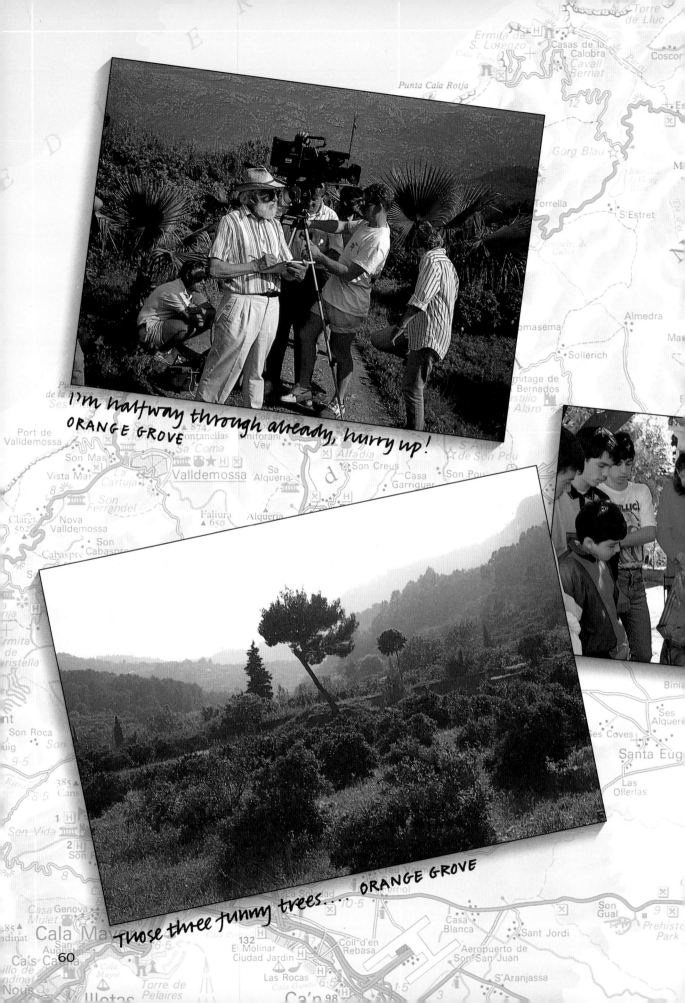

I'm halfway through already, hurry up!
ORANGE GROVE

Those three funny trees.... ORANGE GROVE

why did we choose
the rush hour?
PALMA

June's junior
Spanish painting
'class'. PALMA

It's not all serious stuff, this filming business
FORNALUTX

A DAY OUT PAINTING

FINDING A SUBJECT QUICKLY

SIGHTSEEING IN LONDON

Finding a subject quickly can be difficult but, for some students, the biggest problem can be finding a subject at all! Often you can see plenty of things to paint – too many, in fact. The difficulty is which one should you choose? Don't worry, professionals can have exactly the same problem, too.

Falling into an 'around-the-next-corner trap' is something that all of us are guilty of at times. You see a subject you like and you are therefore inspired. But then you wonder if something even better is just round the next corner and, once you're there, you're tempted to look round the next corner as well. And so on you go, continually looking for the perfect painting spot. I am sure that everyone reading this book who has been painting out of doors has done this. I have, and it's very frustrating and time-wasting, especially if you are only on a day

trip. In fact, if you're not careful, you can finish up with no sketching or painting done at all.

The best way to avoid this is to accept the fact that the first scene you see which inspires you *must* be the first one you paint. The reason is simple: you have been inspired, therefore for you the subject *is* perfect. There may well be a better one around the next corner, but that can wait. So when you are inspired, don't look for a better view – paint! Remember that, if you don't, time may not be on your side.

In this book I use the term 'sketching' quite loosely. When I refer to a sketch, it can have been done very quickly and freely, or with time spent on it to give more detail. The first function of a sketch is to gather information for later use at home on a painting but there is also the kind of sketch that I call an 'enjoyment sketch'. This simply means a sketch or painting done for the sheer pleasure of doing it, no matter what the result is. It can stay in your sketchbook for ever or, if *you* feel that it's good enough, it can be taken out, framed and exhibited.

On holiday you will find that a large proportion of the work you do will be enjoyment sketches. My sketch, *left*, comes under this heading. June and I were visiting London for a couple of days on business and, in between meetings, went out to do some sketching. This sketch took only seconds to do. We were near Buckingham Palace and the guards were marching towards us, in all their splendour. I had no time to think if this was the best view, I simply got out my sketchbook and tried to capture the scene, doing what I could before they went past. I had approximately twenty-five seconds, and I was amazed at what I managed to draw in that time.

RIGHT
After a car backfired, the square was full of pigeons flying away.
Watercolour on cartridge,
28 × 20 cm (11 × 8 in)

BELOW
This impromptu sketch took me just twenty-five seconds as the guards marched past.
Pencil on cartridge,
15 × 20 cm (6 × 8 in)

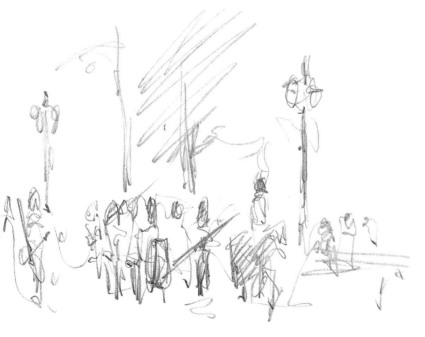

20 second stops in car
LONDON IN THE RAIN

ABOVE
June did this sixty second pencil sketch of people in the rain while we were held up in traffic.
Pencil on cartridge, 20 × 28 cm (8 × 11 in)

BELOW
June kept her pigeons on the ground!
Watercolour on cartridge, 15 × 20 cm (6 × 8 in)

We walked into Trafalgar Square in the afternoon. The sun was low and silhouetting one of the fountains, and the dark shape of the fountain contrasting with the brightness of the water really inspired me. I did the drawing on page 63 with my 2B pencil on cartridge paper but, just as I was ready to paint, the sun dropped behind the buildings for the rest of the day. All the contrast had gone, and the inspiration for my painting went with it. I painted what I remembered, but I think the background buildings could have been darker – then the water from the

fountains would look more sunlit.

At one point while I was painting, the pigeons were frightened by a car backfiring and they all took off in a cloud of flapping wings and falling feathers. When the paint was dry, I immediately put them in and I think these pigeons add a great deal to the sketch.

June had been inspired by the lion at the foot of Nelson's Column, *below*. She saw her subject as a landscape shape, whereas I had been inspired to paint a tall, portrait-shaped image; also June didn't put the pigeons in her painting. It's interesting to see how the same subject is seen by two people quite differently.

The pencil sketch, *below right*, was done while we sat in Russell Square, having coffee. This was definitely an impromptu sketch. The subject was too complicated even to consider really, especially while we were relaxing, but my pencil and pad were there and so I decided to have a go. I started half-heartedly but became more involved and interested as I drew it. This usually does happen once you start – the hardest part is *always* starting! June sat and watched while she enjoyed her coffee!

Later, when we were in St. James's Park, I decided I would do a sketch of Buckingham Palace, *above right*. As we

LEFT
*The rain stopped me
from completing this
sketch or adding
colour – you can't
control nature!*
Pencil on cartridge,
20 × 28 cm (8 × 11 in)

BELOW
*This subject was
really too
complicated to
undertake while
relaxing with a
coffee, but I decided
to have a go. Then I
got absorbed in it!*
Pencil on cartridge,
20 × 15 cm (8 × 6 in)

reached the end of the park, the sky was
growing darker by the minute. The palace
looked extremely regal against a very dark
background of storm clouds. I hoped to
put colour on the sketch if the rain held
off, so I quickly started to draw the scene
with my 2B pencil. I had just reached
halfway through the drawing when the first
large raindrop bounced off my pad. A
rather disappointing end to the palace but
working outside can present us with
problems that are out of our control. These
must be accepted as part of the job in hand
– there is always another day.

On our way home, as we drove through
the busy London streets, June did some
very quick pencil sketches of people
scurrying along with their umbrellas held
high. One of these sketches is shown on
the opposite page, *above left*. This took June
just sixty seconds while we encountered
yet another traffic hold-up. When you are
doing quick sketches like this, where speed
is vital because of the movement of your
subjects, you can really only get a 'feel' of
things. The object of this kind of exercise
is to learn through observation, with your
brain registering what you're doing as you
draw each line. The more you practise
drawing people or moving animals like
this, the wider your knowledge and the
better your work will become.

A MISTY DAY IN IRELAND

This was the first time that June and I had been to Ireland and we were really looking forward to it – I was there to take part in *The Gay Byrne Radio Show*. Unfortunately, it was raining heavily when we touched down at Dublin airport. It's a good thing that rainy weather can't spoil a radio broadcast, at least!

However, the following morning the weather had cleared and, before returning to England, we had several hours to spare – a perfect painting opportunity. We went to Dun Laoghaire, on the coast, where there's a long harbour wall that stretches a considerable distance out to sea. We decided to walk right out along this 'promenade' so that I could do a sketch looking towards the town. As we started to walk, the sun broke through some hazy mist to the right of us and the view looking directly into it was breathtaking. It wasn't the buildings, which were quite ordinary; it was the effect the sun had on the whole scene. The sky was a soft pearl grey and, as it merged into the buildings in the distance, the sun was catching the rooftops, which were wet after the overnight rain and shining like silver. The sea was swelling around the rocks and the man-made jetties and, where the sun was hitting it, the water had turned into a cauldron of moving light. I simply had to paint this scene, *right*.

I started by drawing in my sketchbook – naturally I had to wear my sunglasses, as

This was as far as I got before the sea mist devoured everything!
Watercolour on cartridge,
20 × 28 cm (8 × 11 in)

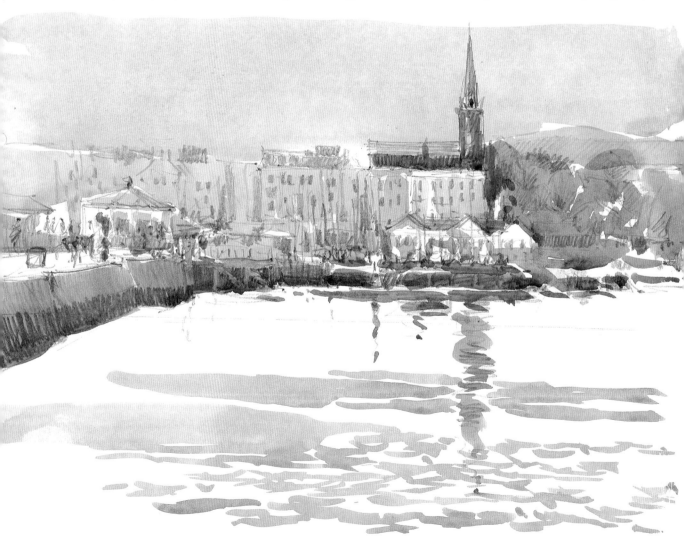

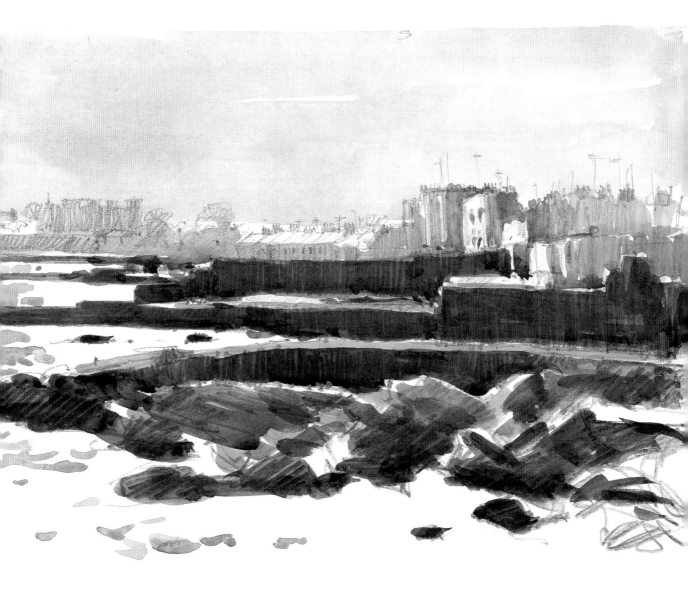

I was looking into the sun. I did a lot of heavy shading on the jetties and rocks, and also shaded the houses. The secret of making the sunlight work on the painting was to leave the brightest parts as white paper and make everything else very dark. Naturally the houses in the distance were painted softer to give the impression of recession. When I had finished, I was really pleased with the result. I feel it has captured that early morning sunlight.

We then walked out along the harbour wall until I found another view of the town that inspired me. I started the painting, *left*, by drawing first with my 2B pencil. Since I was going to paint it, there were some areas where I didn't do much tonal work with the pencil as this would be done with the brush. However, I was only about two-thirds of the way through painting, when a sea mist came down and the whole town disappeared from view. June and I could hardly believe it – it had happened within minutes! Now, although if we turned round, we could see the sea end of the wall and the sea itself still, in front of us the town was no longer visible. It was a strange feeling. All I could do was add a few more accents with my brush and call it a day.

Although the sketch still works and I like it, I wish I could have got more out of it. I would have made more of the bandstand with the green roof, left of the picture, and suggested some reflections in the sea from the buildings. However, it will always be a wonderful reminder of the Emerald Isle on that misty day.

I was inspired by the contrast of the extreme darks and lights as I looked into the sun.
Watercolour on cartridge,
20 × 28 cm (8 × 11 in)

67

SALISBURY IN SEPTEMBER

After arriving in Salisbury late one September morning, we took an early lunch and then set off through the busy streets in search of a good painting spot with the cathedral as the centre of interest. We walked round the town on a raised causeway which runs through the water meadows and, from it, found a clear view of the cathedral, *right*. I decided that this was my painting spot.

At that moment, the sun came out from behind a thin layer of clouds and bathed the cathedral in soft light. I found it very difficult to concentrate at first. The sun was warm and I felt a deep flood of nostalgia as I looked towards the cathedral. John Constable often painted in this area – who knows, nearly two hundred years ago, he might have painted from this very spot.

I decided to do my painting 35 × 50 cm (14 × 20 in). I must admit that I found the spire quite difficult to draw: the shape is so subtle that a pencil line moved only a fraction one way or the other can give you the wrong proportions. The trees were created from just one wash of subtle greens, with a darker tone of the same colours painted over in carefully selected

areas. The one thing that I think the painting has achieved is the majesty of the cathedral, with its solid structure rising regally from its natural surroundings. Incidentally, the day we were there, the steeple was being repaired but I have left the scaffolding out of my painting.

Our next stop was an old mill, now a hotel and restaurant. After two and a half hours of painting, I was glad to find out that they served tea! Then we found a spot by the river where we had a good view of the mill and I did the pencil sketch, *below right*. I don't think I have ever seen so many ducks. When I was sharpening my pencil, they were rushing around picking up the pencil shavings, thinking it was food! This was not the easiest drawing to do, as nothing seemed to line up with anything else and there were almost no straight horizontal lines – just look at the roof. I started with the horizontal line at the edge of the footpath, then drew the verticals for the three water tunnels. I then used these positions as my guide to establish all the windows and the doors of the mill. Once that was done, the rest was reasonably easy and enjoyable – even if the ducks were very noisy! While I was doing this sketch, June spotted a couple of swans and sketched them, *below*.

June sketched these swans as they cleaned and preened themselves.

Pencil on cartridge, 15 × 20 cm (6 × 8 in)

SWANS

ON THE DEVON COAST

When June and I went to Bigbury Beach in Devon with my two artist sisters, it was a cool, blustery but sunny day. Just right for a day out painting in the fresh air, or so I thought!

Eventually we all found our painting spots and began to work. I was the only one working in oils and I was enjoying it and thinking how lucky I was to be on the beach painting when, for no apparent reason, the wind suddenly picked up and started to blow very hard. Under normal circumstances, I can cope with this but here I was on soft sand – the type that runs through your fingers – and when the wind picks this up, it's like being in a mini-sandstorm. I was three-quarters through the painting when this started and I found I was painting sand into the work. My palette and paints were full of sand, and my paint rags had sand stuck all over them. I tried to finish the painting but, eventually, had to give in to the elements and abandon it. Luckily, June, sitting behind a rock and facing the other way, had managed to do a good watercolour sketch, *below right*.

June was lucky – when she painted this, she was sitting behind the rocks and out of the strong wind.
Watercolour on cartridge, 20 × 28 cm (8 × 11 in)

I was feeling a little dejected as we packed up and set off to find somewhere else to paint, out of the wind and not on the beach. But it was one of those days when – for me, at least – nothing seemed to go quite right. None of the painting spots we found really inspired us until, in the early evening, we finally ended up in a huge car park at the side of the river at Kingsbridge.

I looked up the river towards this picturesque town and was immediately inspired by what I saw. I knew my luck had changed. The weather was cool but the sun was out and the wind had dropped. The water was as still as a millpond, as you can see from my painting, *above right*. Everything went perfectly, except when a yacht that I had just drawn slowly pulled away in front of me and sailed off down the river. I had to smile – it would happen *today*! So, with my rag, I wiped the drawing of the yacht off the painting. Remember, accept the unexpected when you are working outdoors. Don't blame yourself, it's just part of life!

Well, I really did enjoy painting this picture – it was worth all the previous disappointment. I painted the trees on the right and the water thinly, enabling the Yellow Ochre underpainting to show through in places, which helped to give the impression of a warm evening glow. This is in contrast to the white house. I made this cool by adding a touch of Cobalt and a little touch of Crimson Alizarin to it. This kept it in the distance and also made it a focal point.

June decided not to draw this view. Instead, she sketched some children who were watching me work, *below right*.

In spite of the rather unproductive day and because of the company of other artists and my final painting, I still enjoyed myself. Remember that it really doesn't matter how many sketches you do on a day out, as long as there is one that you are really happy with. It will make it all worthwhile.

*I really enjoyed
doing this one.*
Oil on primed
hardboard,
25 × 30 cm (10 × 12 in)

*June sketched these
children while they
watched me paint.*
Pencil on cartridge,
10 × 23 cm (4 × 9 in)

A PAINTING PICNIC
IN JERSEY

During a week's holiday in Jersey, in the Channel Islands, we had a day out painting. We were staying with friends who are also artists and, having organised a picnic lunch, we drove to a beautiful, quiet headland, overlooking St Ouens Bay.

The day was very warm but hazy, with no bright sunlight. With distant views, this type of sultry atmosphere actually helps a painting. Instead of it being too bright and looking like a picture postcard, the colours become subdued and low-key, and very atmospheric.

We spent twenty minutes or so seeking a painting spot and, once we had found it, it was picnic-time. Finding your spot before eating is very important because, while you enjoy your picnic, you can be observing the view you are going to paint. Although you are only seeing this as a background to eating and chatting, your subconscious 'painting mind' will be absorbing the scene. So, when you start to paint, you will understand it and already feel quite familiar with it.

I painted in oil on primed hardboard, *right*, size 25 × 30 cm (10 × 12 in), and June worked from a view which was behind me and higher, on cartridge paper with watercolour, *below right*. Her painting was 20 × 28 cm (8 × 11 in).

There are two points of interest when comparing the two paintings. Firstly, although one was painted in oil and the other in watercolour, the overall colours are very much the same in each picture. Secondly, look at the hill, top left. June has made hers much steeper, while I have elongated mine. In fact, I have 'spread' my painting, while June has tended to 'squeeze' hers up. We all see things differently. In fact, I don't know whether my drawing is wrong or June's is right. Perhaps they both differ from the actual place – who knows? It really doesn't matter. The important thing is that they both give an impression of the scene.

When we returned that evening, I painted the misty sunset, *below*, which was a very simple watercolour. I achieved this with only three washes: the sky and water first, then the distant headland, and finally the tower and foreground rocks.

This misty sunset was achieved quite simply with only three washes.
Watercolour on Whatman 200 lb Rough, 10 × 27 cm (4 × 10¹/₂ in)

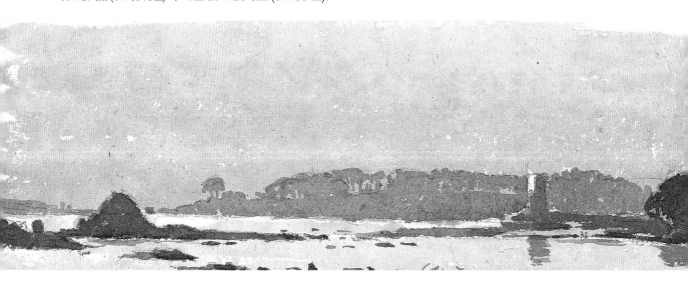

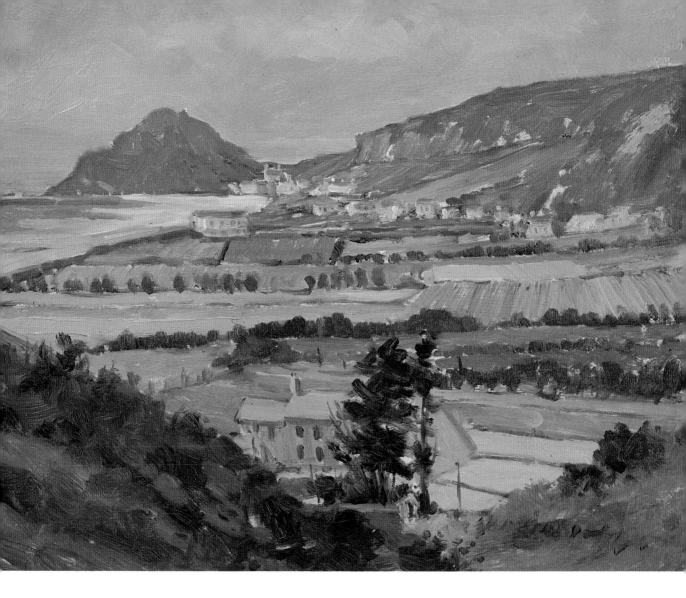

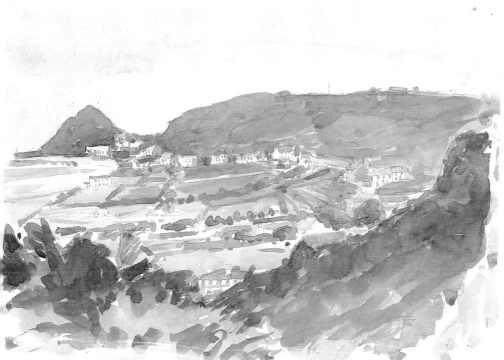

ABOVE
I painted this scene after our picnic lunch.
Oil on primed hardboard,
25 × 30 cm (10 × 12 in)

June painted the same scene in watercolour.
Watercolour on cartridge,
20 × 28 cm (8 × 11 in)

ABOVE
An Austrian traffic jam!
Pencil on cartridge, 15 × 20 cm (6 × 8 in)

BELOW
I did this sketch in ten minutes while we stopped for coffee.
Pencil on cartridge, 20 × 28 cm (8 × 11 in)

AUSTRIAN COACH TRIP

A few years ago, June and I went on a coach trip to Europe. Travelling all day between cities or countries, you have plenty of time to see the countryside from the coach, but you have to be prepared to take every opportunity for sketching when the coach stops for meals and short 'walkabouts'. All you need is an A4-size sketchbook and watercolours. If you are reasonably quick with oil paints, keep a small pochade box with you inside the coach. Don't make the frustrating mistake of having any of your sketching equipment stowed away in the outside luggage compartments, or you won't be able to get to it until you reach your destination at the end of the day!

As you travel through the countryside, finding a subject quickly is really important. These subjects may not necessarily be ones that would make marvellous paintings but don't worry. Think of the sketches you do during this type of journey simply as ones for practice and enjoyment – a way of keeping your hand in and, of course, a visual diary of your holiday.

Look at the pencil sketch, *above left*. We were passing through a small Austrian town which was in the middle of its annual summer fair. What a day to pick to go

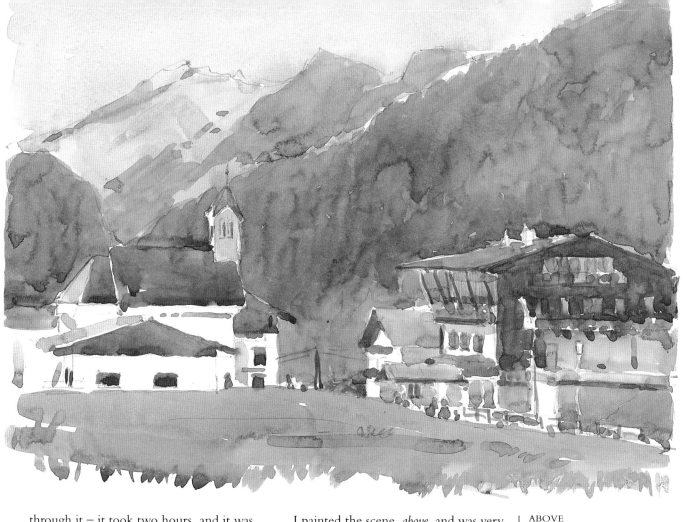

through it – it took two hours, and it was lunch time, too! Still, why worry about food when you've got a sketchbook in your hand? I did a quick pencil sketch of the traffic jam in front of us. I also did other sketches as we moved slowly through the streets. And the sketch, *below left*, was done outside a restaurant where we stopped for coffee. I had about ten minutes before we were ready to go. I would never use these two sketches for painting from at home, but they are visual memories – enjoyment sketches to remind June and me of our holiday.

Later that day we had a stroke of luck. Someone in the coach had left his jacket, with his passport, at our very late lunch stop. We were in the Austrian Alps by a hotel in a small hamlet when this was discovered. Most of the passengers disembarked, while the coach went back for the jacket. We were going to be there for about an hour, so there was time for a much longer period of painting.

I painted the scene, *above*, and was very conscious of the strong, predominant colours: green, red, very dark brown and white. I'm more used to painting misty English landscapes, with their subtle shades of greens and greys!

June did very little painting on the actual journey. She did the quick pencil sketches, *below*, from the moving coach.

ABOVE
Our unscheduled coach stop.
Watercolour on cartridge,
20 × 28 cm (8 × 11 in)

BELOW
June's quick sketches from the moving coach.
Pencil on cartridge,
8 × 12 cm (3 × 4¹/₂ in)

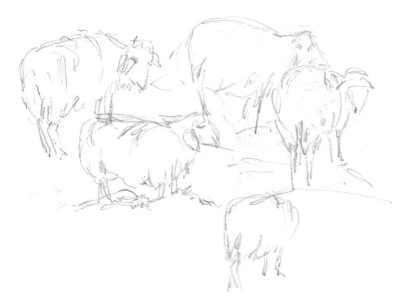

Time to get our breath back while June sketched some sheep.
Pencil on cartridge, 20 × 28 cm (8 × 11 in)

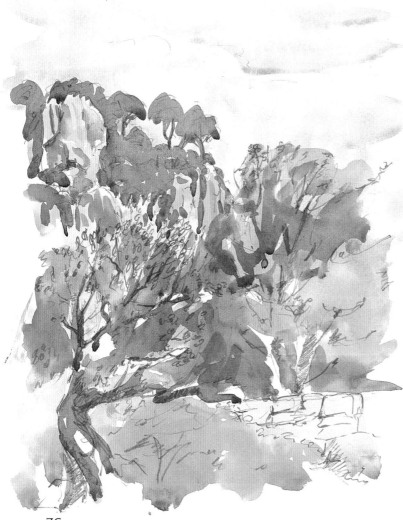

PAINTING PRACTICE IN MAJORCA

When we were in Majorca for the filming of the television series, June and I had a day off before the first day's shoot. We decided to wander around the village of Deyá, where we were staying, and get in some painting practice for the next day. I had previously seen a view of the mountains that I was determined to paint. This was from the wall of the church right up at the top of the village that I later painted on camera, see page 31. On the way June sketched some sheep, *above left*, and this provided us with a good excuse to stop and rest for a while out of the hot sun.

I did my painting, *right*, on cartridge paper and drew it with my 2B pencil. I put quite a lot of shading in the drawing, which took about twenty minutes. I then started to paint from the sky downwards. You can see how the pencil shading on the mountain, which shows through the paint, helps to give the impression of a sheer rockface. Remember, when you are in a hot country, you must use bags of water when you are painting, or your washes will dry too quickly! On page 94, I explain how I coped with this problem on a particularly hot day in Greece.

June didn't do a painting from the village, but when we eventually returned to the villa she painted the watercolour, *below left*, from the terrace. I love the freedom of the painting and, in particular, the trees at the top of the cliff. They are painted so simply – just a few brush strokes – but they really make the painting.

LEFT
June did this from the terrace.
Watercolour on cartridge, 28 × 20 cm (11 × 8 in)

RIGHT
In a hot country, you must always use bags of water or your washes will dry too quickly.
Watercolour on cartridge, 28 × 20 cm (11 × 8 in)

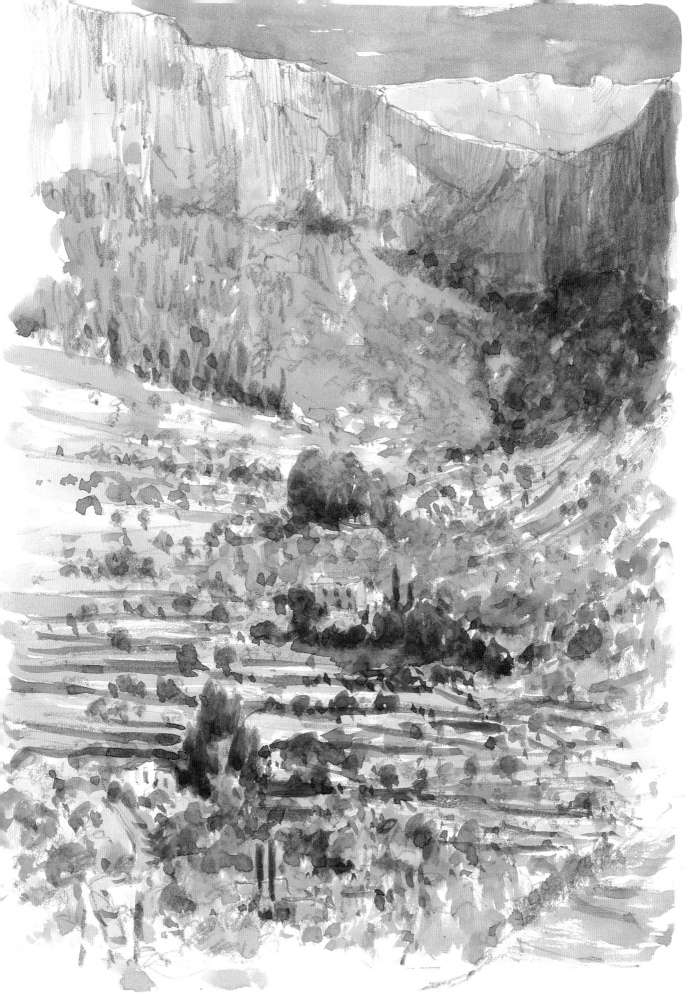

A WEEK'S PAINTING HOLIDAY

FOLLOWING IN JOHN CONSTABLE'S FOOTSTEPS

When June and I decided to take a week's holiday in 'Constable country' in and around Suffolk, it was early spring – usually an inspirational time of the year for painting. Naturally, before you go on any holiday, it's wise to start thinking about what type of subjects you wish to paint, what size paintings you will do, which mediums you will work in, and so on. This form of planning is very good for building up enthusiasm. But at the same time, you mustn't feel too disappointed if real-life conditions on holiday don't meet up to your plans and expectations. Be prepared to adjust to the situation!

This was definitely the case on this particular holiday. The weather had been really springlike until the day we left home for our hotel in Dedham. Then, suddenly, it turned extremely wintery with fierce winds and heavy rain! Our luck definitely wasn't in on this occasion and, apart from a few hours of sunshine, the weather

stayed cold and rainy for the whole of our week's stay. Although this sort of thing can be a real disappointment, never give up. Be prepared to paint from your car or from under cover, if necessary.

If you have to resort to working from your car, *always keep your equipment tidy*, so that you can locate things quickly and easily. Searching all over the car for a pencil can be extremely time-consuming.

On our first day, June and I went to Pin Mill on the River Orwell, home of many old Thames barges, some in working condition and others just skeletons, half-submerged in the river mud! I sketched and painted the barge, *below*, from the car.

June didn't start so well in the rain and she was glad when we stopped work to have lunch at a picturesque old pub, which was partly resting in the river mud. When we came out of the pub an hour later, we looked at each other in amazement – the rain had stopped! We rushed to the car, got our gear out and quickly walked upstream until we had a distant view of the barges and the pub.

We both painted the same scene from the same spot but notice how June has closed in and only painted half of the left-hand barge, *below right*. Looking at my painting, *above right*, the silhouette of the tall trees on the left of the pub are in front of a hill and so the light area of 'sky colour' halfway up behind them should be painted in dark, as it is to the left of them. When I had finished the painting, I noticed that I hadn't painted this area in but I decided that the light against the dark of the trees leading down to the pub actually helped the painting. So I used my artistic licence, and left it the way it was!

This was a complex subject for my first sketch of the holiday. I had to concentrate hard, but I was really happy with the result.
Watercolour on cartridge,
20 × 28 cm (8 × 11 in)

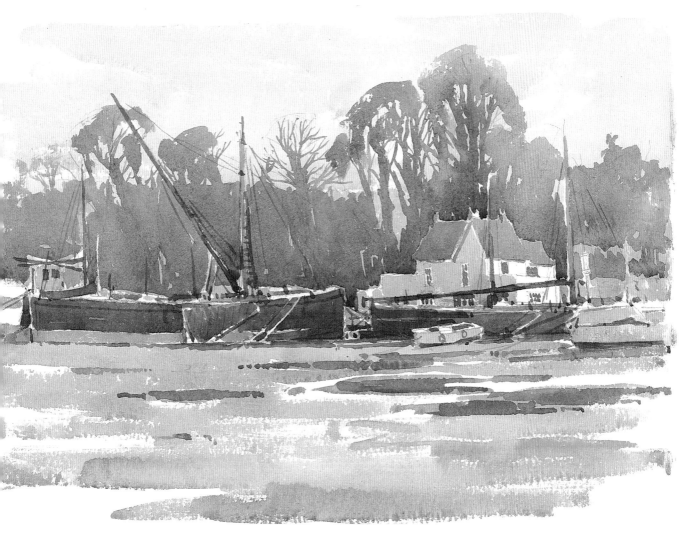

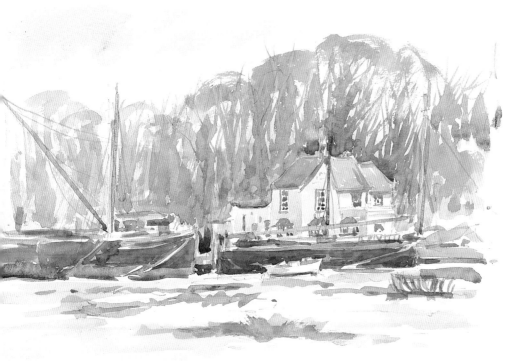

ABOVE
Use your artistic licence like I did with the trees, but don't overdo it.
Watercolour on Bockingford 200 lb, 28 × 38 cm (11 × 15 in)

June's scene was painted much more freely than mine and this helps to give the painting a lot of life.
Watercolour on cartridge, 20 × 28 cm (8 × 11 in)

We decided to go to the coast the following day and arrived at Dunwich in rain and gale force winds. But the clouds were dramatic, although they were moving very fast. I decided to do a watercolour, *right*, concentrating on the sky, from inside the car. I worked the sky very wet, allowing the colours to mix together on the paper, but notice how I left areas of unpainted paper to give the impression of the light and fast-moving clouds. I painted the distance dark to contrast with the lighter sky on the horizon and the foreground has just been suggested with a few horizontal brush strokes. The suggestion of a large puddle in the foreground helps to capture the atmosphere of rain and stormy weather.

If you look at the painting carefully, you will see, just to the left of centre, a 'paint run' from the top of the paper to the bottom. This happened when I started the sky. The paper was at a very steep angle because it was resting against the steering wheel and, with a fully-loaded brush, the paint had to run somewhere! If something like this happens, unless it ruins my painting, it doesn't worry me when painting outside. Don't ever expect to produce a clear and pristine painting outdoors – if your oil painting finishes up

with some insects stuck to it, or your watercolour has a few unwanted splodges, it all adds to the spontaneity of the painting. The object of working outside from nature is to *observe and learn*.

In the afternoon, we moved on to the pretty village of Walberswick and June did the watercolour sketch, *below right*. It has been painted very freely and has not been laboured or overworked, which can easily be done, especially when painting buildings. When you paint a scene like this, always try to concentrate on the 'whole' not on detail.

I painted another part of the village just after a rain squall had passed, *below*. I was looking into the sun, which had just been uncovered by the storm clouds, and I worked on cartridge paper, drawing the scene and then shading the tones in with pencil. I then painted over this with watercolour washes. I painted a Yellow Ochre wash over the sky first, making it paler in the centre. When this was dry, I painted the dark cloud area, watering this down as I got near the houses. I painted the silhouette of the village and trees over it when it was dry and then painted the foreground. Notice how I left two windows light, this helps to break up the strong silhouette shape across the picture.

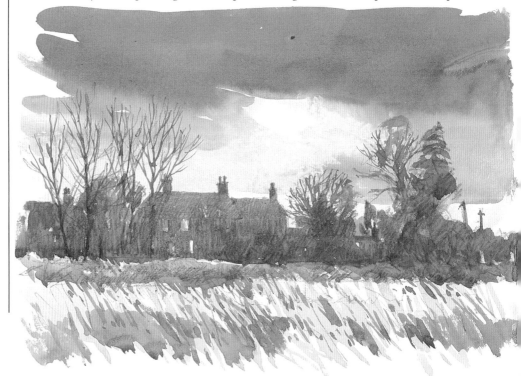

The sun had just been uncovered by storm clouds when I painted this.
Watercolour on cartridge, 20 × 28 cm (8 × 11 in)

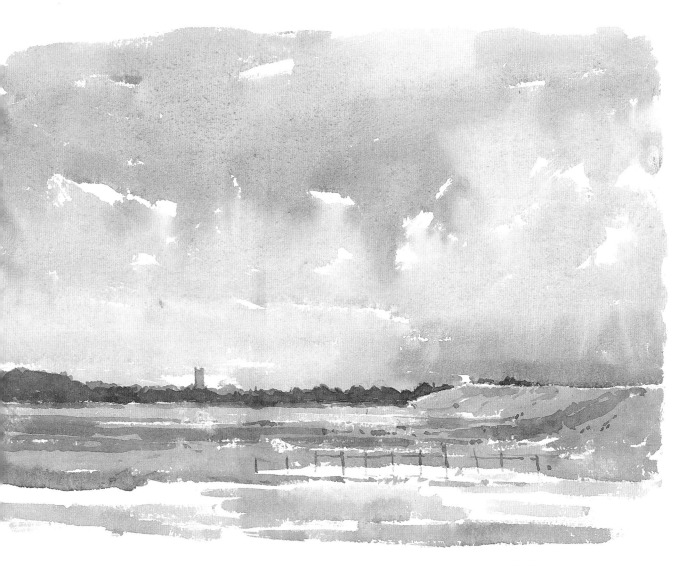

ABOVE
I did this watercolour of Dunwich Beach, concentrating on the dramatic sky.
Watercolour on
Bockingford 200 lb,
28 × 38 cm (11 × 15 in)

June's watercolour of the village is painted very freely as usual. Notice how simply she has worked the windows.
Watercolour on
cartridge,
20 × 28 cm (8 × 11 in)

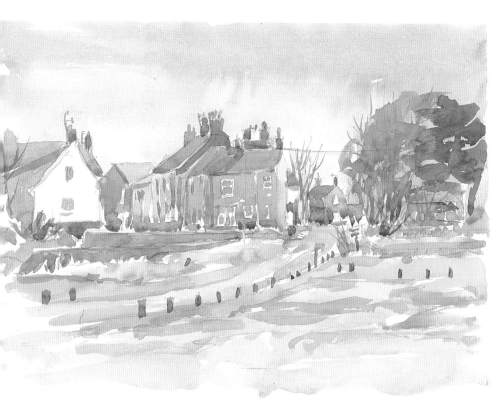

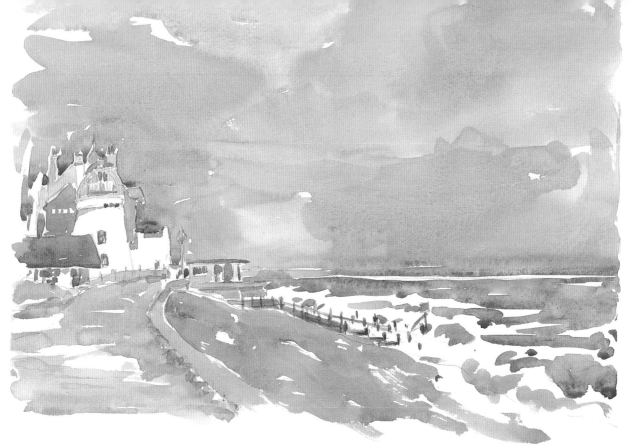

It had been suggested that we visit Aldeburgh, where there are traditional Suffolk fishing boats pulled up on the beach in front of Victorian buildings of all shapes and sizes. It was still blowing a gale and raining when June and I arrived, but there were some breaks in the clouds with a chance of the sun coming out. We found a painting spot overlooking the beach and, from the car, we had a fabulous view. The sun wasn't out but, using the white of the lighthouse and the white of the foaming waves to contrast against the dark sky, buildings and beach, it was perfect for a watercolour.

In my painting, *above right*, the lighthouse and waves were left as white paper and the sky was painted without leaving any white areas. I went for a high horizon to give a long, dramatic roadway leading up to the buildings.

June did exactly the opposite in her painting, *above*. Her horizon is low, giving more prominence to the sky and she has also given a freedom to the waves which I like very much.

We both felt very pleased with our paintings and by now it had stopped raining, so we went on to the beach to find a spot to paint the boats. But the wind was blowing so hard that we could hardly stand up in it, let alone hold our sketchpads steady, so unfortunately it was back to the car once more!

This time, we parked on the sea front, from where we could see boats perched on top of the beach. June's sketch, *below right*, is very simple in content – just two boats and a fisherman's hut – but for me it really does bring back memories of that part of the coast. It was drawn on cartridge paper and then painted with simple washes. The sky was worked very wet and the colours were allowed to mix together. The boats were left as white paper, except for the sterns, which had a pale wash painted on to give them dimension. Notice how the beach and grass has been painted simply and lots of white paper has been left unpainted. With a watercolour, leaving areas of white paper unpainted, especially in the foreground, often helps the painting by giving it contrast and sparkle. With experience and by looking at other artists' watercolour paintings you will learn what white paper to leave unpainted.

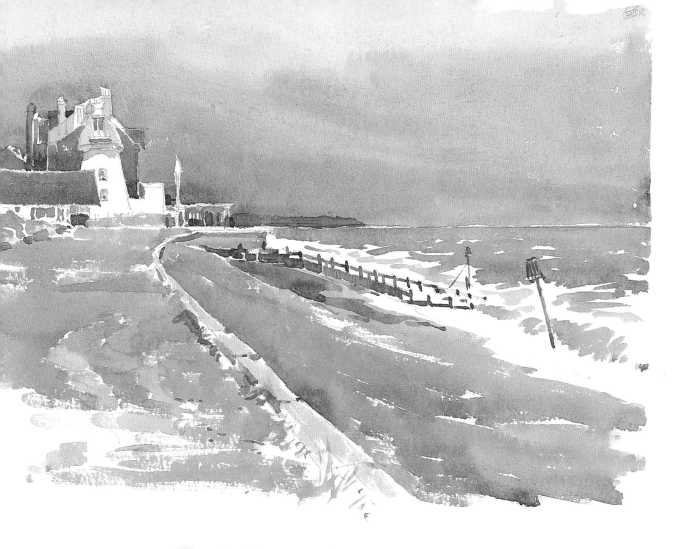

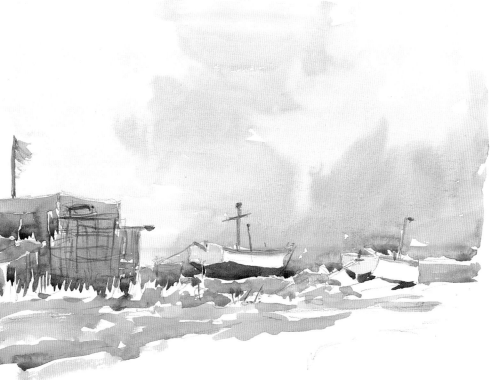

ABOVE
My painting of the lighthouse has a high horizon – every artist sees a scene quite differently.
Watercolour on Bockingford 200 lb, 28 × 38 cm (11 × 15 in)

June's simple watercolour sketch of Suffolk fishing boats – nothing is overworked.
Watercolour on cartridge, 20 × 28 cm (8 × 11 in)

While we were at Aldeburgh, I decided to do the drawing, *centre right*. I worked on cartridge paper, using a 2B pencil. This is the type of sketch that I could use at home to do a painting from. I also took a photograph of the scene, just in case I needed more information to work from at a future date.

We left Aldeburgh in the late afternoon and drove back to Dedham feeling very fulfilled with what we had done, despite the weather. As we passed through the village, we decided to stop in the riverside car park, to check out what scenes there were for another day.

The light wasn't good but, as with the lighthouse painting on page 83, if the white of the cottage and the foam of the water coming through the lock were kept as white paper to contrast against the landscape, the scene would make a good watercolour sketch. Immediately June had her sketchbook out and started working on her sketch, *below*, there and then!

John Constable painted here at Dedham Mill on many occasions. This scene is of the mill pool with the mill just out of the picture on the left. I decided to do it in pencil only, *above right*. Once again, June and I have observed the scene quite differently. I have captured a much wider view and the right-hand wall of my lock is much longer than hers is. However, it really doesn't matter which of us has come closest to the real thing. Although drawing is very important in structuring a painting and representing a real scene, it is not necessarily a bad painting if some of the proportions or relative sizes of objects are not totally correct. The object of a painting is to convey the mood and feeling of a place, not to produce a complicated architectural drawing of it. Naturally, there are times when a drawing has to be very accurate – with portraits of wild animals, railway engines or airplanes, for instance – but *don't become a slave to absolute accuracy*. Remember, above all, enjoy your painting!

June couldn't resist this lovely view of Dedham Lock.
Watercolour on cartridge,
20 × 28 cm (8 × 11 in)

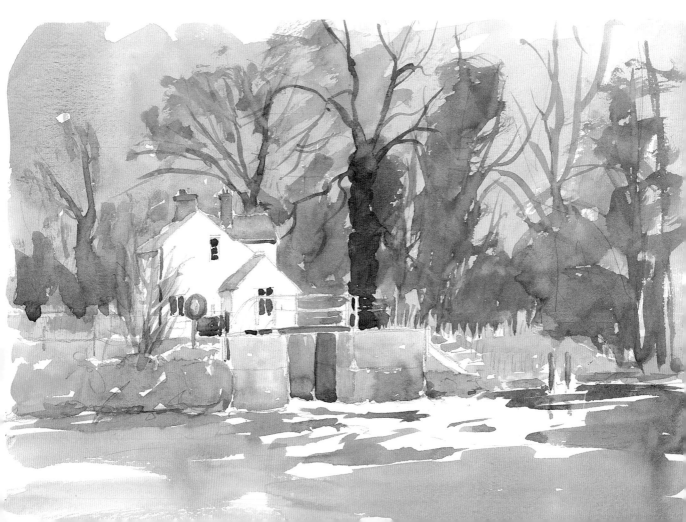

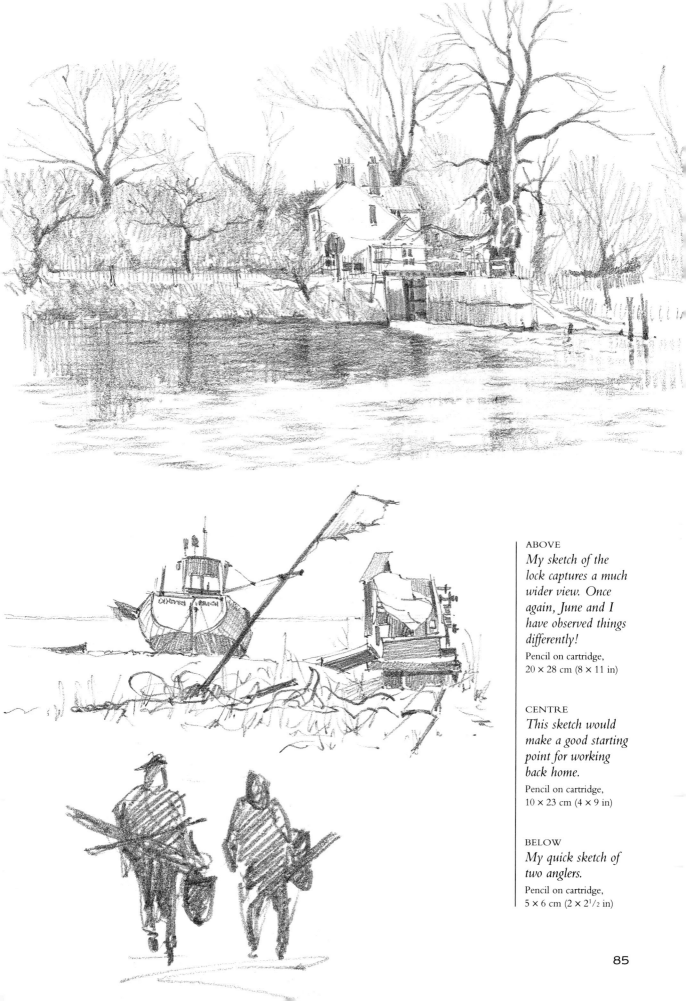

ABOVE
*June's painting of
Dedham Church
has just the right
light on it and is
full of atmosphere.*
Watercolour on
cartridge,
28 × 20 cm (11 × 8 in)

the pad! From a closer position, I painted the church in oils again, but this time I left the river out. This is reproduced in the Gallery on page 120.

After lunch, we went to Flatford Mill. This was the location for John Constable's famous painting, *The Hay Wain*. In that painting, the hay wain was being driven across the mill stream towards the opposite bank and through a gap in the trees. I did the oil painting, *below right*, from the gap, looking back at where the hay wain would have been coming from. The house in the picture is Willy Lott's cottage, which is positioned on the left of Constable's painting. As I did my painting, it gave me an odd feeling, knowing that I was looking at the very spot where Constable would have stood when he was working on his painting!

The river bank was overgrown here, so I didn't have the problem of a horizontal line that I had with the first painting of the church. Here it is broken up by reflections, dead grasses and the crumbling river bank. I was very happy with the painting and I actually finished it just in time. As I was working the last brush strokes, it started to rain again!

The final day of our holiday in Suffolk was spent sightseeing, as the rain got even worse. But I did manage to do an oil painting in the car of Walberswick, looking from across the river. This is also reproduced in the Gallery section, on page 120. The painting is a little flat, as there was no light and the scene got greyer as I painted it, but it really has captured the atmosphere!

When we got home, we found that the whole of Europe had shared this extreme weather, so we hadn't gone to the wrong place to paint! But, despite everything, we both thoroughly enjoyed the holiday. The area of England we visited is overflowing with painting possibilities and I would thoroughly recommend anybody to go painting there. June and I will definitely be back again – hopefully next time in sunnier weather!

After a day-off sightseeing in Ipswich, we decided to paint around Dedham again. It was our first day without rain, although it was still very windy, and I wanted to do an oil painting. Eventually I decided on a scene looking over the River Stour towards Dedham Church, *above right*. I was happy with this painting but I am not sure about the straight line running across it, created by the river bank. Sometimes I look at it and I like it, other times I'm not so sure. No doubt you have paintings that have that effect on you – we all get them!

June did the watercolour sketch, *above*, of the church from further along the river bank and this turned out to be a real beauty. It is very freely painted but is full of atmosphere and the light on the church is perfect. June told me that some of the freedom came from the sketchpad coming towards her brush, blown by the strong wind, rather than her brush going towards

My oil painting of Dedham Church – this was our first day without rain!

Oil on primed hardboard, 25 × 30 cm (10 × 12 in)

Flatford Mill is where John Constable painted The Hay Wain. *Now I was really following in his footsteps!*

Oil on primed hardboard, 25 × 30 cm (10 × 12 in)

A PAINTING HOLIDAY WITH STUDENTS

WORKING IN A GROUP

Organized painting holidays with a group of students and a tutor are becoming increasingly popular. For keen amateur painters, the combination of receiving good tuition from a professional painter, working in a group with like-minded people, and the chance to visit interesting and inspiring places, often makes a painting holiday the ideal holiday. I know that my organized painting holidays are tremendously over-subscribed and everyone always says how much they have enjoyed them and how they feel that their painting has benefited. June and I enjoy these holidays, too!

On one such painting holiday, we took eighteen students to the Greek island of Hydra. This small island only has one main town, with picturesque white-washed buildings overlooking the harbour. There are no motor vehicles except for one refuse lorry and the quayside is always bustling with activity because anything delivered to the island has to come by boat, be unloaded and then packed onto a mule, donkey or handcart.

On our first morning, everyone was eager to start work and, armed with our painting gear, we went down to the harbour. Eventually everybody found a painting spot looking across the harbour and settled down to work. Twenty minutes later, disaster struck! We all looked up and watched in dismay as a big ocean-going liner slid in front of us along the quay and docked.

This needed some quick thinking because the ship had completely blocked out our view across the harbour. I collected all the students together and told them I would do a demonstration for them, and my subject would be the liner, *right*. After the disappointment, everyone was pleased with my suggestion. By now it was getting quite hot and to sit and watch someone else work for a while wasn't such a bad idea!

I sat on the quayside, looking towards the stern of the ship. To my left there was a small wall supporting some rough ground and everyone else clambered up onto this and made themselves comfortable to watch me paint. However, I had just begun my drawing when the refuse lorry came along. There wasn't enough room for both of us

June's pile of builders' rubble. Notice how the foreground is not detailed.
Watercolour on cartridge, 28 × 20 cm (11 × 8 in)

on the quayside, so I gathered up my bits and pieces and jumped up onto the wall. Once the lorry had slowly driven past, I was able to jump down again and continue with my drawing, but I had just finished it and was ready to start painting when there was a further problem. The liner suddenly gave a loud blast on its horn and started to reverse from its berth towards the open sea! A little way out, it dropped anchor. We found out later that this was in order to leave the quay clear for other craft to come in.

Quick thinking was needed again, so I decided to paint the picture and test everyone's powers of observation – including my own – on the colours and details of the missing boat. I had one

further interruption just as I settled down to do this when the refuse lorry returned! Despite all this, my demonstration turned out successfully and everyone enjoyed it very much. Notice how I have painted the background – the town – very simply. As the foreground is rather busy and complicated with the ship, I feel that this helps to balance the painting.

By now, everyone was keen to start work again, so new painting spots were found, away from the quayside. June found a massive pile of builders' rubble and stone round the corner from the harbour and, standing erect in the middle of it, was a bust on a stone column, *left*. What an unusual and original subject but doesn't it say 'Greece'!

I painted the water with plenty of horizontal brush strokes to give the impression of movement.
Watercolour on cartridge,
20 × 28 cm (8 × 11 in)

On another morning we had arranged for a local fishing boat to take us round the island and drop us off at a small harbour for the day.

The sea was calm and the sun was out when we slowly made our way out of the main harbour and towards a distant headland at the end of the island.

We had been travelling for about half an hour when the approaching headland started to disappear in a dense mist. Within minutes we were in the middle of the mist, too. Our skipper told us that we could go no further and instead he would turn round and head back to another small harbour on the other side of the town, further up the coast. I won't say that we had a mutiny on our hands, but everyone was extremely disappointed because this meant an extra hour in the boat – and no painting! I decided that a quick injection of painting was needed, and suggested that everyone should sketch someone or something in the boat.

I then did a quick demonstration by sketching one of the students sitting at the stern of the boat, *right*. I drew this on cartridge paper with my 2B pencil and put in some shading, mainly in the strong shadow areas: his hat, face and chest and also the anchors. I didn't attempt to draw any features of the boat, apart from the anchors. The painting was done very simply. A very pale blue mixed from French Ultramarine, Crimson Alizarin and a touch of Yellow Ochre was painted down the sky and up to the edge of the boat. When this was dry, a darker wash with more Yellow Ochre was painted over for the distant headland. Another darker wash was worked in broken brush strokes for the sea. Notice how it is dark where it hits the stern of the boat. This gives shape to the boat, which was left white. The student's white shirt was also left as white unpainted paper.

This unlaboured sketch is a typical holiday study that anybody can try. It's uncomplicated: the subject matter is simple and it is painted very freely. Because of this, if you have confidence in yourself, you can do this type of painting reasonably quickly. My sketch took me twenty minutes.

June has used white paper here to contrast against shadows, conveying strong sunlight on a white building.
Watercolour on cartridge,
20 × 28 cm (8 × 11 in)

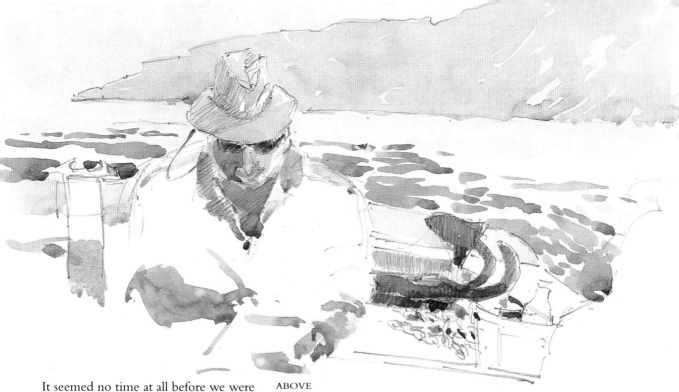

It seemed no time at all before we were landing on a small wooden jetty at the little harbour. By now it was lunchtime and extremely hot, so everyone else went for a quick dip in the sea to cool down while June and I organised lunch for us all at a taverna overlooking the harbour. Our meal, sitting together at a long table in the shade, was a most enjoyable experience. Then it was time to set to work again.

In between helping the students with their paintings, June found time to paint the little church just above the harbour, *left*. She did this on cartridge paper, capturing the strong sunlight by leaving the white-painted stone as unpainted paper. The blue door, painted in French Ultramarine, gives a strong accent to the painting and it provided the focal point which inspired June to paint the scene.

I also found time to paint the boat, *below right*, just for the sheer joy of doing it. Remember, whatever subject you choose to do – however small or simple – you can always learn a little more and gain experience. This applies to *all* artists, professionals included.

This turned out to be one of our most memorable days on the island of Hydra. At the end of the day, we left the little harbour with some excellent paintings and wonderful memories.

ABOVE
Apart from the blue collar, I didn't put any more work into the student's shirt. This helped to make it prominent.
Watercolour on cartridge, 16 × 28 cm (6^1/$_2$ × 11 in)

BELOW
This was a sheer enjoyment sketch.
Pencil on cartridge, 13 × 10 cm (5 × 4 in)

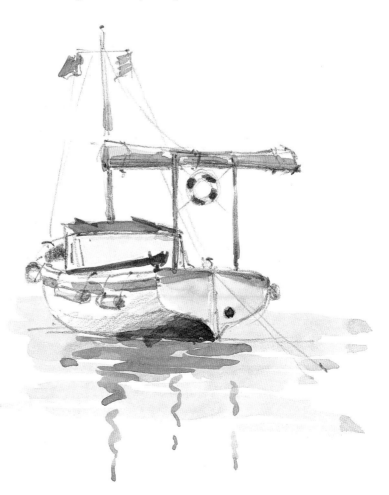

One of Hydra's tourist attractions, which we didn't want to miss, was the trek by mule up to a small church overlooking the town and harbour. This proved to be great fun, although some of the students decided to walk with the mules rather than risk the actual ride. The saddles were wooden and not really made for sitting on, being square on top and at the sides, so the comfort looked minimal! In the morning, our mules were already waiting for us outside the hotel, together with a pair of donkeys to transport our equipment. This was fastened onto them by the mule handlers in record time. Imagine – twenty people's painting equipment being temporarily fixed to two donkeys *and* staying on!

We started our long trek through the town and up the steep hill on a rough track to the church. This took about an hour and it was extremely hot but, to my surprise, I discovered that riding on my mule wasn't difficult or too uncomfortable. In fact, everyone seemed pleasantly surprised with the journey. When we reached the church, the mules were taken back but the two donkeys were left for us to sketch.

Before we went on this trip, I had sketched two groups of donkeys and mules while sitting at a table on the quayside, having a coffee with some students. I drew

with a 2B pencil on cartridge paper and the first is shown *below*. The actual scene was quite complicated and there were boats in front of me, more mules with their handlers on the quayside, tourists, cargo, and a backcloth of buildings. This is where the artist can do things that a camera can't. All I wanted was the mules and donkeys, with a suggestion of the cargo left on the quay. So I concentrated on this part of the scene and left everything else out. The most important aspect of this sketch was to make sure that one of the mules was recognisable. This is important. Whatever group of

RIGHT
The start of the mule trek.

BELOW
All I wanted here were the donkeys with their loads.
Watercolour on cartridge,
8 × 20 cm (3 × 8 in)

objects you are painting, whether it's a crowd of people, a number of boats in a harbour, or animals, you must draw one or two of the objects in the foreground so that they are recognisable. Then the viewer will accept that the rest of the group are the same. I made sure that the mule on the right was a complete drawing, and therefore recognisable. I then did the sketch *above*. I like both sketches, which took about fifteen minutes each but, looking at the second sketch *now*, I have spotted for the first time that the dark mule on the left behind the white one has

no back legs! I always say that, when sketching moving animals, the object is to observe and get used to them, and not necessarily to make a picture of them. Well, I couldn't have found a better example than this!

Back at the church, our first exercise was to have half an hour drawing the two donkeys in five minute sketches. This wasn't easy, but everybody enjoyed it and we had some excellent results. June and I had a go in between helping the others. June's five minute sketch is *below left* and mine is *below right*.

The reflection of the lamp post should be more to the left. Apart from this and the dark brown donkey's missing legs, I like this sketch!

Watercolour on cartridge,
18 × 23 cm (7 × 9 in)

BELOW LEFT
June's five minute sketch.

Pencil on cartridge,
13 × 15 cm (5 × 6 in)

BELOW RIGHT
I was lucky – my donkey was quite still for five minutes, unlike June's which moved around.

Pencil on cartridge,
10 × 10 cm (4 × 4 in)

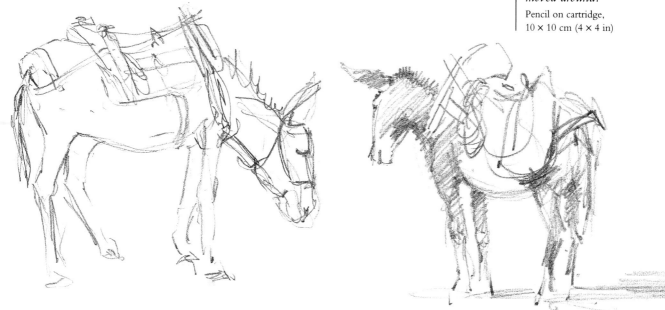

BELOW
June's sketch from the church.
Watercolour on cartridge,
24 × 20 cm (9¹/₂ × 8 in)

OPPOSITE
I was lucky with painting the wash for the sea. It was very hot and so I used bags of water and kept my fingers crossed!
Watercolour on Bockingford,
38 × 28 cm (15 × 11 cm)

In cold weather, paint can take a long time to dry and it can be extremely frustrating having to hold back your enthusiasm while you wait for your work to dry. Here in Greece, however, because of the heat, the students were having difficulty in putting on a wash, as the paint was drying too quickly. It's amazing how often the elements are against an artist!

I decided to do a demonstration to show them how to combat the heat. There is only one answer – you must use *bags of water* and work as quickly as you can. This should keep the paint wet long enough for you to apply washes of a reasonable size.

I purposely chose a scene with a large uninterrupted area which had to be painted with a wash. This was the large expanse of harbour, sea and distant hills, *right.* I worked on Bockingford paper and didn't wet the paper before painting. I drew the picture first with a 2B pencil and then drew a horizontal line across the paper for the bottom of the hills. Next, I mixed a large watery wash of French Ultramarine, Crimson Alizarin and a little Yellow Ochre. In the next palette in my paint box, I mixed a smaller wash – but with plenty of water – of Yellow Ochre, Crimson Alizarin and a little French Ultramarine.

I started with the first wash, then added the Yellow Ochre colour mix into it on the paper and let it mix together as I painted down to the bottom of the hills. I then used the French Ultramarine mix wash and continued down to the buildings on the right and, adding more French Ultramarine into the wash, continued down to the harbour wall. Below the houses on the right, I added some of the Yellow Ochre wash on the paper to blend with the blue sea. Inside the harbour, I added Hookers's Green No. 1 to the wash and continued down to the roofs of the houses. Incidentally, I left two white shapes of unpainted paper in the harbour to represent boats.

From the top to the bottom of the harbour took about four minutes, using my No. 10 sable brush. If I had been slower, the wash could have dried as I was working it. The rest of the painting was made up of small washes for the roof tops, sides of buildings and so on – so there wasn't a problem with these areas. I must admit I did expect to have a problem somewhere on the wash with the heat, but it was one of my lucky days!

June did a sketch on cartridge paper looking to the side of the harbour, *left.* It has some lovely colours and movement to it, and I particularly like the dark hill and houses at the bottom. I also like the way it has finished running into white paper. Remember, you don't always have to fill all the paper to make a watercolour.

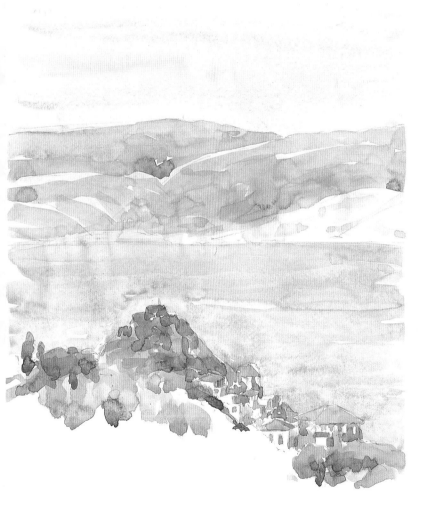

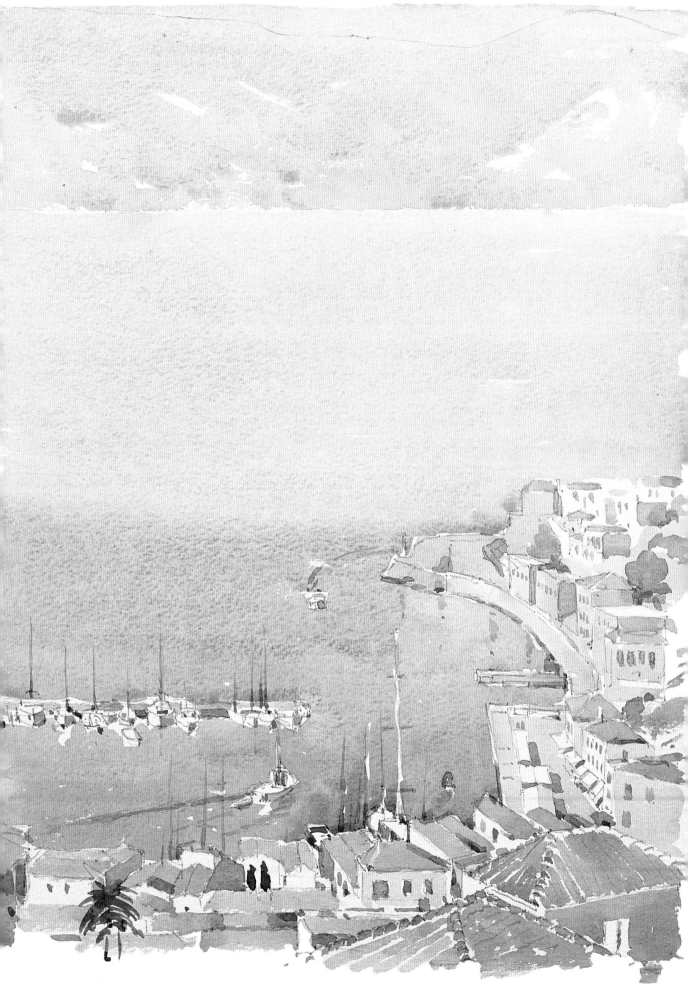

Towards the end of the holiday, we had a very windy day with some rain in the morning, so we decided to work indoors. I started with some demonstrations and then asked all the students to do ten minute sketches of each other working. In this way, everyone was sketching live models. Done as a team with everybody in the same boat, in addition to painting well, everyone thoroughly enjoyed the exercise. When people are put under pressure, they usually do very well and surprise themselves.

June joined in this exercise with her sketch, *below*. Notice how she hasn't tried to paint the faces as portraits. This would have looked out of character with the rest of this freestyle painting. In ten minutes you can only aim for an impression of the subject. The object of a 'quick' exercise is not to make a perfect picture, or to become the fastest painter in the world, but to observe your subject carefully, to see shapes and to be able to simplify them, as in the faces in June's painting. Observe dark areas against light areas; learn to spot tonal values quickly and easily, and remember not to fiddle! Because you are doing this in a short, concentrated effort, all your senses are sharpened and your ability to learn is speeded up considerably.

This type of exercise was one of the first things I ever learnt at art school. Try some quick exercises yourself – on any subject – but do be honest when timing yourself. It's very easy to cheat with five extra minutes here or there. I've done it myself, but June usually keeps me in check! In my book, *The Half-Hour Painter*, every painting was done in just thirty minutes. Remember, it is not the end result that matters – it's what you learn in the half-hour that counts.

On our last day, we stopped at a waterside café in Athens on our way to the airport and I painted the boat, *above right*, from our table. June started the same subject. As usual, I left my coffee to get on with the sketch but June, true to form, had her coffee first. When she was halfway through her painting, we had to move to another table much further down the quay as the waiters wanted to clean the tables that had been occupied by our group. Fortunately for me, I had finished my sketch and was ready for my cold coffee but, sadly, June couldn't carry on with hers. She was very disappointed, as she had done the drawing, *below right*, which is always the hardest part.

June's ten minute sketch of our students.
Watercolour on cartridge,
20 × 20 cm (8 × 8 in)

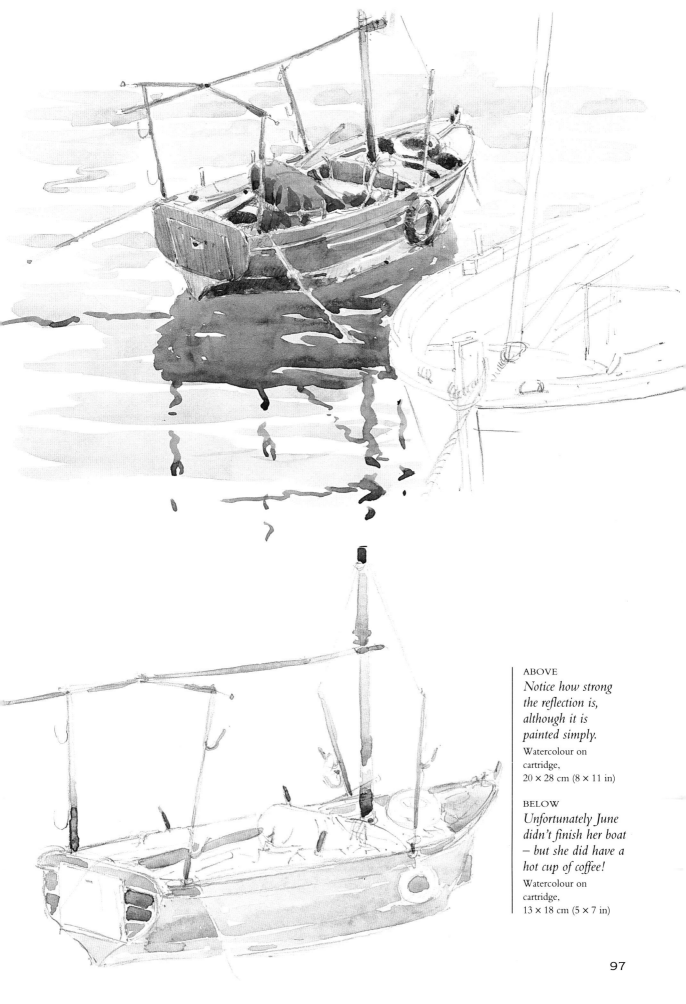

ABOVE
Notice how strong the reflection is, although it is painted simply.
Watercolour on cartridge,
20 × 28 cm (8 × 11 in)

BELOW
Unfortunately June didn't finish her boat – but she did have a hot cup of coffee!
Watercolour on cartridge,
13 × 18 cm (5 × 7 in)

97

BACK HOME

*Working at home from
holiday sketches and photographs*

PAINTING A COMPLICATED SCENE

Selecting the most interesting part of the photograph to paint helped me to simplify this complex harbour scene.
Watercolour on Whatman 200lb Not, 38 × 28 cm (15 × 11 in)

To paint a complicated scene from a photograph, you often need to start by *simplifying* the photograph. If you look at the photograph, *above*, of Hydra harbour in Greece, you will see one way I have tackled this problem – I have only painted half of it!

Remember, when you take a photo, the camera takes in everything the lens can see and, although you may not have been interested in the whole scene, that is what you will get in your photograph. So always look at your photograph to see what compositions you can create by using different sections of them. I always take colour slides because I can enlarge these back home on my slide projector and this helps me to find different paintings within my photographs.

My painting of Hydra harbour is relatively simple in format. The left side of the photograph was uninteresting for painting, so I decided to start just to the left of the yellow building. To keep the tower in the 'centre of interest' position on my painting, I cut off some of the right side of the photograph as well.

Naturally this composition had to be portrait-shaped, but I also felt that this helped the painting and made the tower more prominent. I left out the two boats at the bottom left and also the one at the bottom right of the photograph. With a complicated scene like this, their omission helped to keep the foreground simple and understandable.

Focal Point

When looking at a picture, especially if it's a complicated scene, a point of reference for the eye to rest upon is very important. Here I have used the tower but have exaggerated the dark cliff-face behind to help the tower to stand out – *light against dark*. I have kept the buildings in the foreground very simple, especially the ones on the cliff-edge. Notice also how I have put very little detail into the boats and that, although in the photograph the water is quite dark, I have painted it a little lighter and left plenty of white paper to represent light and movement.

The golden rule with a complicated scene is to simplify where you can, without losing the atmosphere of the scene. Study your photo first and take your mind back to the day you took it. Try to relive the moment – it all helps!

WORKING FROM A PHOTO AND A PENCIL SKETCH

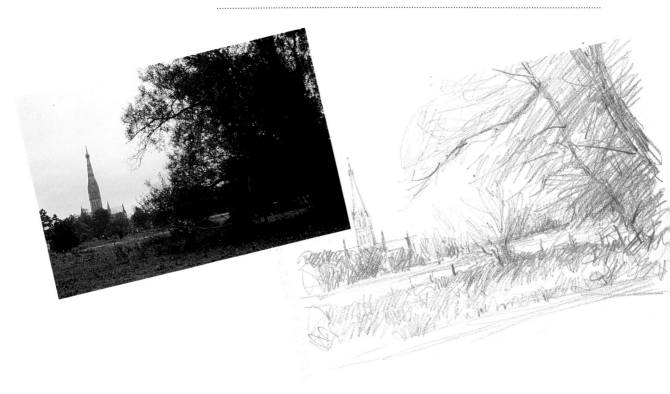

Pencil on cartridge,
20 × 28 cm (8 × 11 in)

With my pencil sketch, a photograph to show me additional form and shape – and my memory – I had bags of information to paint Salisbury Cathedral when I got back home.

I did the pencil sketch, *above*, when June and I had our day out in Salisbury (see page 68). The photograph isn't my best effort – it's very dark, in fact. But with the pencil sketch and my memory, as well as the photograph, I had enough information to work with back home in the studio. I decided to do an acrylic painting on canvas, size 40 × 50 cm (16 × 20 in). I don't take my acrylic paints with me on holidays but I do work at home with them. If you would like to learn about acrylic painting, my book *Learn To Paint Acrylics* will help you get started.

Shape and Form

When I have a pencil sketch from which to work, I use the sketch as my main guide and the photograph as a back-up to show me correct forms, shapes and colours. In my sketch here, I did not bother too much with the drawing of the cathedral, as I knew I was also taking a photograph.

The proportion of the drawing and its composition on the canvas come mainly from the sketch, although in this sketch the elements are very similar to the photograph, and there was not much compensating to do. I did, however, use a canvas that was taller in format than the sketch, to give more height and majesty to the picture. I painted the cathedral and the fields in front of it bathed in sunlight, although when I took the photograph the sun was behind clouds. But this is the beauty of working back home from sketches or photographs – *you* can dictate the weather conditions!

Notice how I kept the trees dark and in a low colour-key. If I had painted them bright green, they would have been too colourful for the cathedral and it would have lost some of its importance. I exaggerated the sunlight on the fields, which helps to give distance between the end of the foreground shadow and the

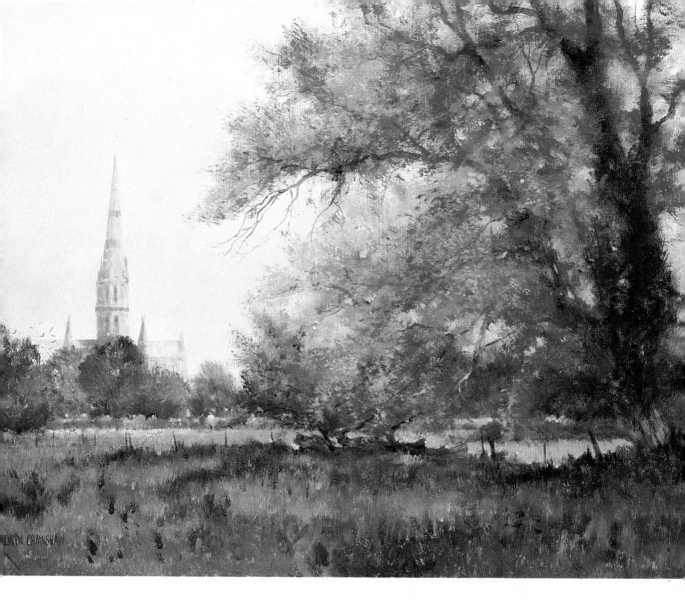

cathedral. The two figures walking towards the viewer in the field in the middle distance also help to show scale. This is subtle but very important.

When working at home, use your sketch as the base, your imagination to help you develop the sketch and, where necessary, the photograph to check your work. However, before you start your painting, do take time to study the sketch and the photograph first, to help trigger your memory and to get your mind back to the moment when you took the photograph and drew the sketch. If you find this difficult to do at first, don't worry – with practice, it will become *easier!*

Acrylic on canvas,
40 × 50 cm (16 × 20 in)

Although these two figures are small in the painting, they help to show scale, which is very important. This detail is reproduced actual size.

WORKING FROM A PENCIL SKETCH

Pencil on cartridge,
20 × 28 cm (8 × 11 in)

*The object of the
pencil sketch was
to record the main
features of the scene.
The detail below
is reproduced
actual size.*

When you have only a pencil sketch to work from, it is important that it provides you with as much information as you require. Avoid doing complicated pencil sketches of man-made objects, town scenes, boats, harbours or historic places to start with, unless you take photographs as well. Although notes can be made on the sketch or on another piece of paper, unless you have gained wide experience of working outside, I suggest that you tackle

easier subjects first. It is very difficult to work from just a pencil sketch when colour and form have to be correct to make the painting plausible.

Instead, start by sketching scenes where colour, shape and form are not critical, such as landscapes with hills in the distance and trees. If a branch on a tree is drawn too long or too short, too high or too low, no-one will worry. However, a ship's mast put in the wrong place, a door made into a window, or a red-brick building painted as stone could make your painting disastrously inaccurate. So keep to the simpler subjects, or remember to take your camera as well!

The sketch, *above,* is one that I did in Jersey, overlooking St Clement's Bay. With this type of subject, a photograph isn't necessary. If you put a rock in the wrong place or make the trees a little larger or smaller, it won't spoil the painting and it will still look like the bay.

Memory

A sketch like this can also be used for working 'different atmosphere' paintings. You must, of course, know where the sun would travel during the day in relation to the drawing. Because you have been to the spot and drawn the view, your

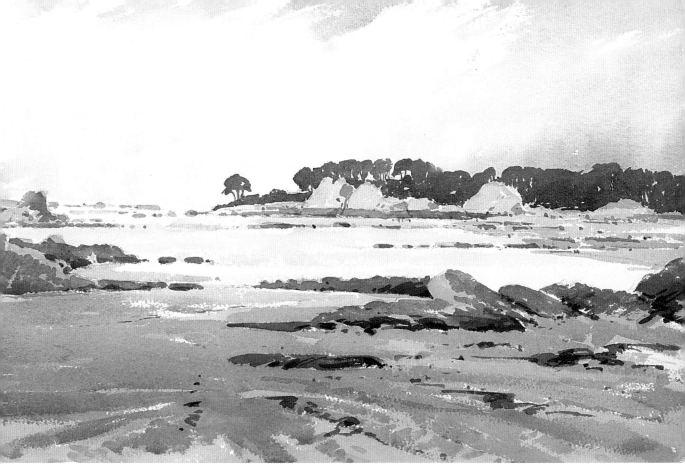

Watercolour on Whatman 200lb Rough,
38 × 55 cm (15 × 22 in)

The trees were painted simply and not overworked but I did add a few tree trunks. This detail is reproduced actual size.

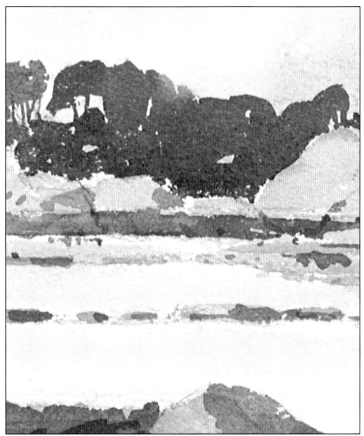

memory holds a mine of information, particularly with the sketch in front of you. When working from a sketch like this, you have an almost infinite choice of colours, depending on the type of weather conditions in which you decide to paint the picture. It could be a sunset, early morning, a misty or windy day – whatever you wish.

My choice was to paint in watery sunlight, after a shower of rain. Notice how I left the water very light in the distance, using a dry brush technique and leaving plenty of unpainted paper. The light area leads you to the focal point, which is the lone group of trees at the end of the headland. Although the subject matter is very simple, I rather like the drama of the picture.

PAINTING ATMOSPHERE

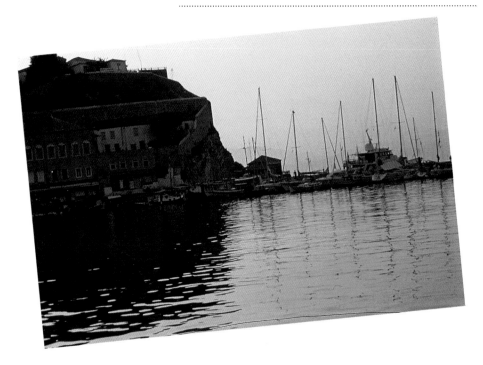

A sunset or late evening scene has a strong visual atmosphere – one that we can all relate to.

Atmosphere is so important in a painting. If a painting is totally without atmosphere, it won't be very convincing. Of course, atmosphere can be created by the subject matter: for example, a painting of a racehorse galloping or a racing car speeding round a sharp bend will give a feeling of speed or daring and skill. This type of painting doesn't rely on the weather or the time of day to get atmosphere across to the viewer. But when it comes to landscapes or seascapes, it's a different matter. Here you need the atmosphere of the day to make the painting come alive.

One of the hardest times of the day to capture atmosphere is around noon on a sunny summer's day. The light is flat and bright and, because the sun is overhead the shadows are very short, or even non-existent, and so you lose a lot of dimension and contrast in the scene. But have you ever noticed in afternoons in late autumn, when the sun is low, how the shadows are long and strong, and the colours of the landscape are bathed with a golden-yellow glow? Each season, time of

the day and type of weather has its own distinctive atmosphere, whether you're looking at an early morning winter landscape, with the sun coming through a fast-disappearing mist, or it's a blustery spring day with the clouds billowing across the sky and the landscape looking fresh and green. These are the types of atmosphere which, when used in paintings, are recognisable to everyone, simply because we have all experienced them and they are dramatically visual enough to be remembered.

Nature's Moods

When painting from a sketch, be decisive about the atmosphere you want to capture. You can't change your mind halfway through. Imagine you are there, on location, experiencing it, and keep that idea in your mind's eye until you have finished the painting.

Naturally, by going outside and experiencing and painting nature's moods, you will gain a far better knowledge of them, but do take photographs too. Photographs taken for atmosphere are far more valuable

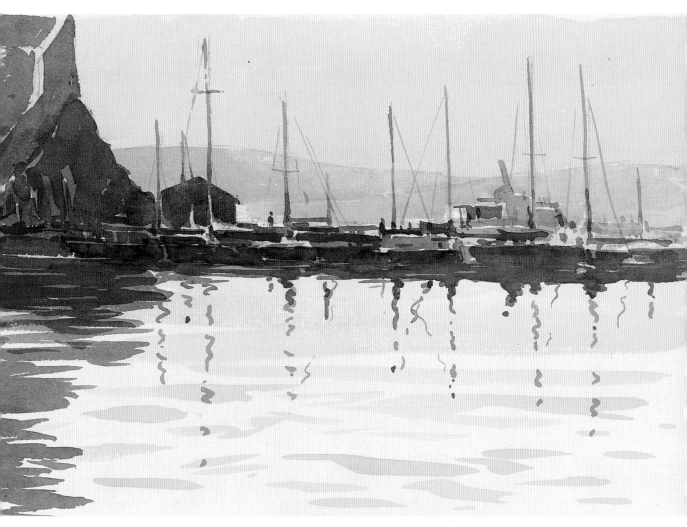

than those which have simply been taken for scenes. Sometimes a particular mood of nature will last for less than a minute, and you couldn't even open your sketch book and get your pencil out in that time! But a camera can capture it for you, to study and learn from, forever.

For this painting, I chose a photograph that I took in Greece when the sun had just gone down. I decided to use a light ochre-coloured paper to help keep the glow of the sunset throughout. I also warmed the whole scene up, by making it yellower. This was how it had been before I got round to taking the photograph. The painting was done in three main washes: the sky and sea first, the distant hills and light areas of the boats next, then the dark silhouettes of the boats and reflections. Finally, I painted a few extra darks on the boats and reflections to add to the atmospheric effect.

Watercolour on coloured paper, 20 × 28 cm (8 × 11 in)

You can see clearly the three main washes that I used. This detail is reproduced actual size.

107

WORKING WITH SOFT LIGHT

I left plenty of unpainted white paper in my painting to give a feeling of soft light on a warm, sultry day.
Watercolour on Bockingford 200 lb, 38 × 28 cm (15 × 11 in)

Working with soft light is really an extension of the last exercise, 'Painting Atmosphere'. The less colour and light you have in a photograph, the harder it is to understand it because you lose shape and form – and that makes it more difficult to paint. Circumstances are, of course, different when you're painting 'on the spot'. Then, if you're not sure about something, you can usually go and take a closer look. Working at home from a photograph, things are more difficult!

You can exaggerate what light and shade there is in the photograph, to give it depth and form. You can also, if you have the experience, put in some shadows, but do make sure that the scene you are painting would get the necessary sun to cast those shadows. Of course, with a landscape photograph, you'll have no such worries. Use it as your subject only, as you would with a pencil sketch, and put your *own* atmosphere into the painting.

In the photograph, *above*, because this Greek street is so narrow, I wasn't sure whether the sun would have much chance of casting shadows. When I came to paint it, I decided to try to give it the atmosphere of a still, warm, sultry day –

the kind where there's no 'blue' sky and not a single ripple on the water. This was very similar to the day when I took the photograph but I did add a little more light into the street. I wanted a centre of interest and used the two figures. Notice how I have kept all the background away from them to give them more prominence. I also kept the yachts very simple and didn't make the underside of the canopy as dark as the photograph, as this would have been too powerful for the painting. Also, I wanted the two figures to be the darkest element.

Unpainted Paper

I left the sky as unpainted white paper, used a *very* pale wash for the distant hills, and left the water and the dresses and material near the two figures as white paper as well. Leaving white paper like this with no strong shadows, gives a feeling of soft, flat light filtering every-where. It also helps to unify the painting.

Notice how the angles in the picture – the street, the line of clothes, and the sloping angle of the canopy – all work together to direct the eye to the centre of interest, the two figures.

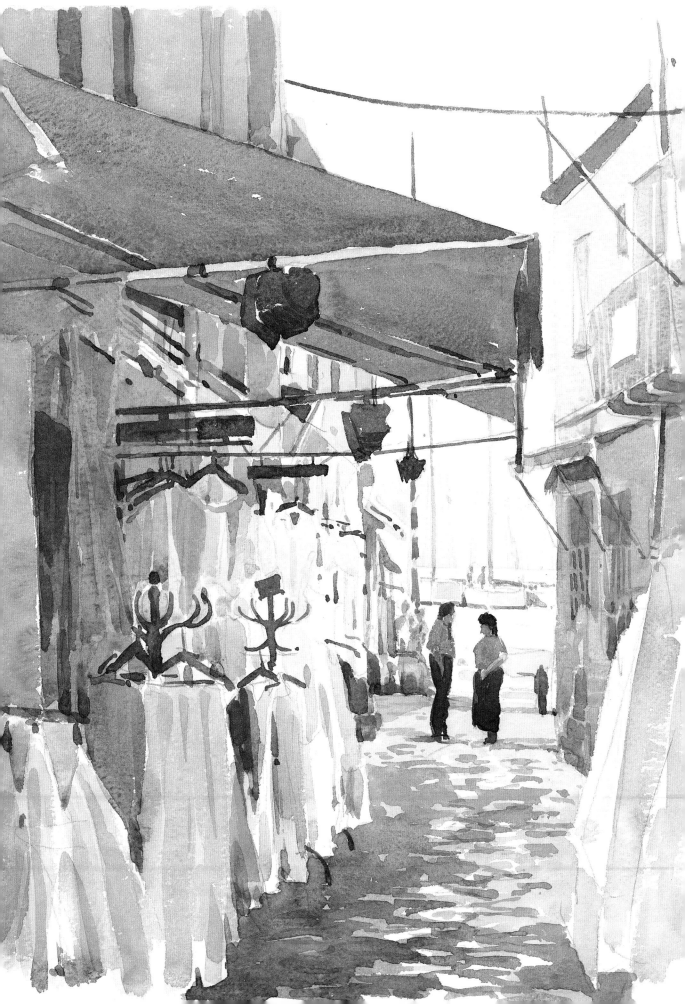

THE IMPORTANCE OF SHADOWS

The photograph has no shadows but I added them to my painting to give the impression of sunlight on a spring day.
Watercolour on Whatman 200 lb Not, 38 × 28 cm (15 × 11 in)

In the last exercise, I didn't use any shadows because there were none in the photograph. Well, the photograph, *above*, hasn't got any either, because it's of a typically dull English winter's day! I could have painted it like it was but, instead, I decided to make it much more exciting by giving it the happier, sunnier appearance of early spring.

Warmth and Movement

My painting shows just how important shadows are to give the impression of sun, warmth and movement to a painting. Because I had decided the sun was out in the painting, I used warm colours. These were my normal ones (see page 20), but with more red and yellow added in the mixes. When I painted the main tree, notice how I didn't try to copy *every* branch exactly from the photograph. If you do this, your painting will become laboured and have no feeling in it – use the photo only as a guide.

I painted the shadows last, when the rest of the painting was dry. The rule of thumb I use when painting shadows in watercolour is to mix a wash of French Ultramarine and Crimson Alizarin as my base colour. As watercolour is transparent, whatever this colour goes over, the underpainting will show through, adding local colour (the colour the shadow is being painted over) to the shadow. This is how I make my shadows and they are never a problem, but you must use *bags of water* when you are painting them – never use the paint 'dry'.

One of the most important uses of shadow is to show *form and contour*. Look at how the shadows of the trees in my painting help to show that the hedge is perpendicular and the path is horizontal. This is simply because shadows naturally follow the contour of anything that they go over. I made the shadows up in my painting and it would be difficult to tell whether they were correct or not. If your shadows are not obviously wrong and your painting looks good, don't worry. Why not try putting some shadows on a painting from one of your photographs?

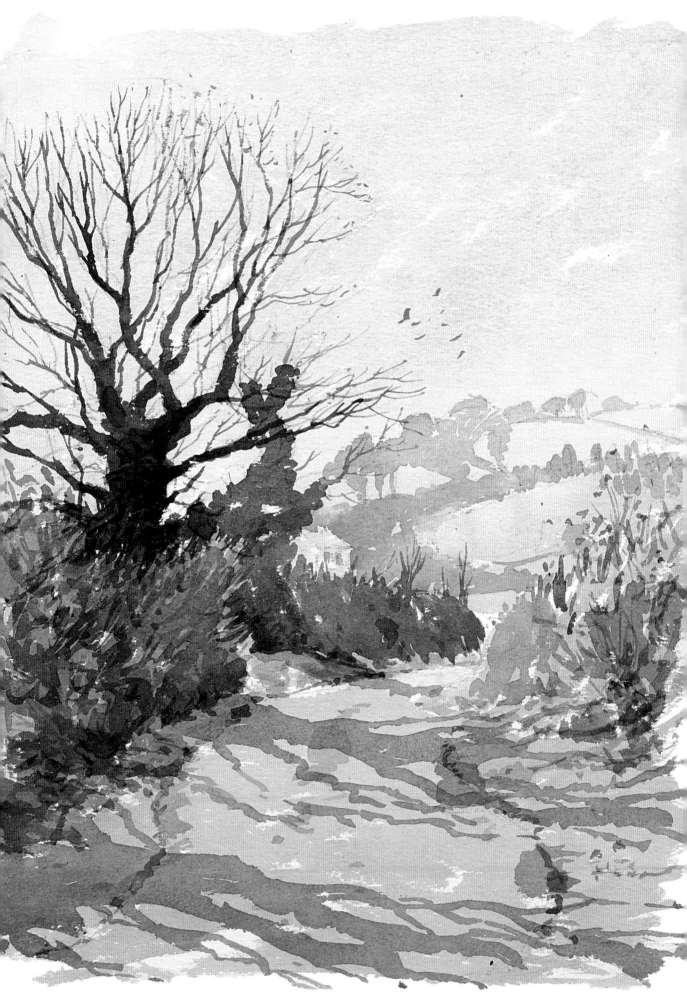

CAPTURING SUNLIGHT

The photograph has too much contrast, but I didn't fall into the trap of copying it too faithfully.

You will know from reading the previous exercise that shadows help to create the illusion of sunlight, and I think my painting of the Acropolis in Athens demonstrates this perfectly.

Look at the photograph, *above*. Incidentally, can you see me in the middle? June took it when I wasn't looking! We were spending the morning sightseeing and painting with our students before we went to Hydra in the afternoon. It was extremely hot, yet the photograph is very much on the cool side, with bluish colours, although the strong shadows indicate that it was warm. I believe this coolness has been created by the camera, or perhaps it's because June and I are not expert photographers and she was shooting into the sun!

Warm Colours

I decided to warm my colours up to help give the feeling of hot sunlight. When you look at the sun, everything becomes silhouetted or darker in tone than normal. June's photograph has more contrast, dark against light, than my painting. The reason why mine is not so 'black and white' is because I didn't fall into the trap of copying the photograph too faithfully.

If you do that, you can lose the charm of watercolour. I therefore kept my painting much lighter in key. The sun is coming from behind the right-hand side of the Parthenon, and so I added more Crimson Alizarin and then Yellow Ochre to the sky as I painted it, using French Ultramarine to start the wash. I continued down the painting, going over the Parthenon and the ground all in the same wash. I didn't paint over my shirt, leaving it as white paper. I also left some white areas on the people.

Painting round the people was done very, very freely. I then painted a wash over the Parthenon, leaving some underpainting showing, by using a dry-brush technique. Then I painted the figures. I started at the left (notice that I missed out the last two people on the left of the photograph, to help my composition) and kept the painting very wet, letting it run together where it wanted to.

When this was dry, I painted a slightly darker tone on the ground, let it dry, and put in the shadows. I used the same colours as in the previous exercise. I usually say that everything in front of a strong light source is darker than normal, but in this painting I have contradicted this

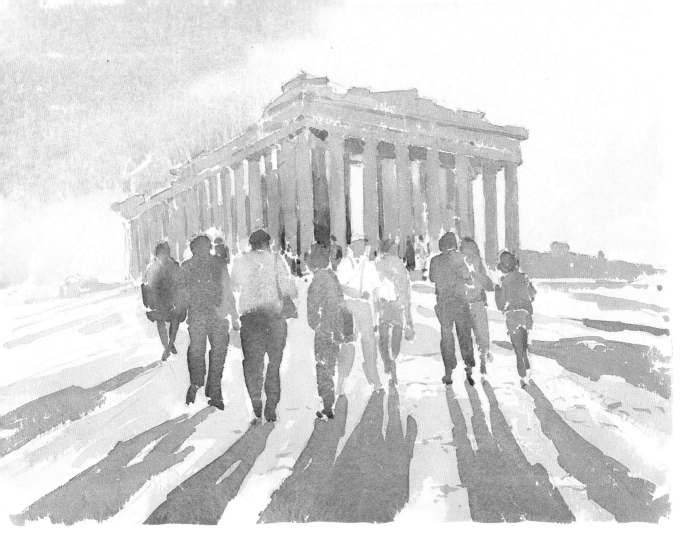

and left my shirt white – in fact, it's the lightest part of the painting. The strange thing is that it doesn't worry me. I think it helps the painting to look very sunny, and it conveys more of a feeling of warm sunlight than we managed with the camera. But then that is why we capture our scenes with a brush! However, remember that the camera can do many things that an artist can't. Used with artistic feeling, a camera and a brush make a very good team.

Notice how the shadows and the unpainted white paper give the impression of sunlight on the Acropolis.
Watercolour on Whatman 200 lb Not, 28 × 38 cm (11 × 15 in)

I painted the figures very freely, allowing the wet paint to run and mix together. This detail is reproduced actual size.

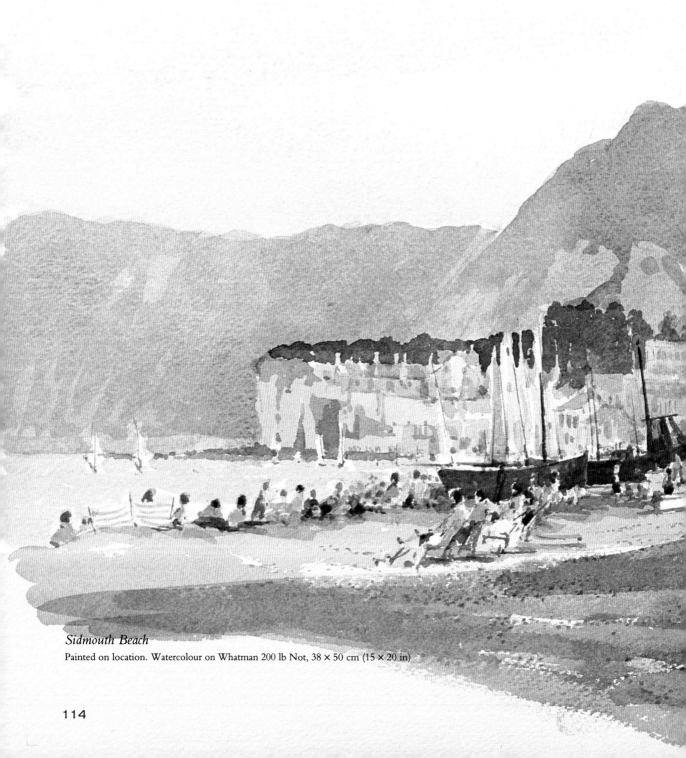

Sidmouth Beach
Painted on location. Watercolour on Whatman 200 lb Not, 38 × 50 cm (15 × 20 in)

Gallery

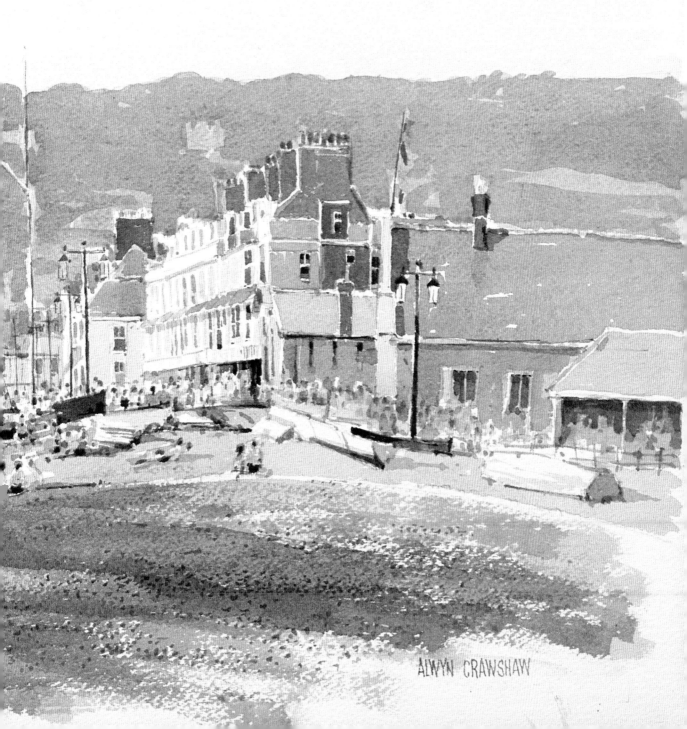

ALWYN CRAWSHAW

Sunlight and shadows, The Lake District
Painted on location. Watercolour on Whatman 200 lb Not, 38 × 55 cm (15 × 22 in)

'Hacienda Vista', Ibiza
Painted on location. Watercolour on cartridge, 20 × 28 cm (8 × 11 in)

From the cliffs at Cala d'Hort, Ibiza
Painted on location. Watercolour on cartridge, 28 × 20 cm (11 × 8 in)

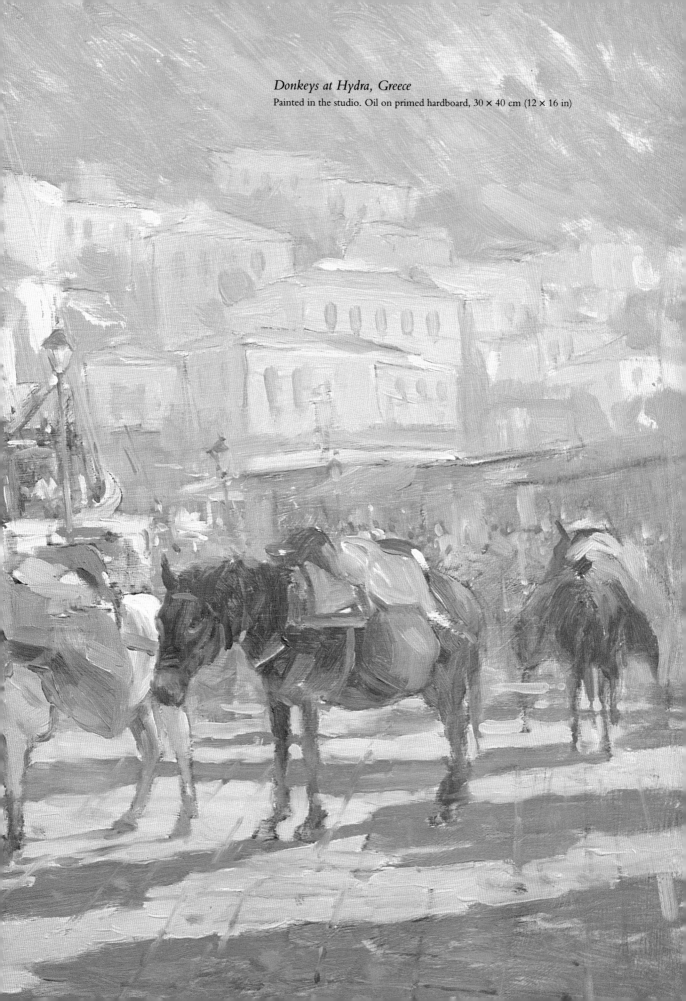

Donkeys at Hydra, Greece
Painted in the studio. Oil on primed hardboard, 30 × 40 cm (12 × 16 in)

Dedham Church
Painted on location. Oil on primed hardboard, 25 × 30 cm (10 × 12 in)

Walberswick, Suffolk
Painted on location. Oil on primed hardboard, 25 × 30 cm (10 × 12 in)

Misty day, Porthleven, Cornwall
Painted in the studio. Watercolour on Whatman 200 lb Rough, 38 × 55 cm (15 × 22 in)

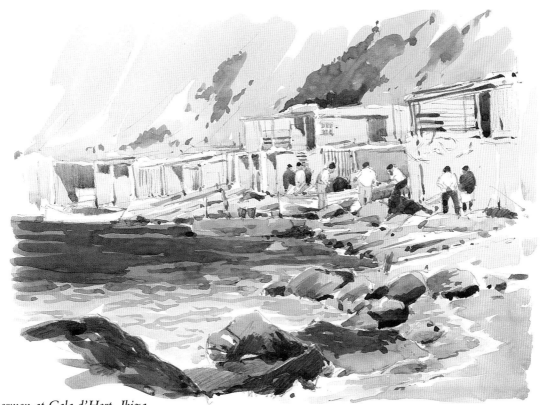

Fishermen at Cala d'Hort, Ibiza
Painted on location. Watercolour on cartridge, 20 × 28 cm (8 × 11 in)

Late evening glow
Painted in the studio. Acrylic on canvas 40 × 60 cm (16 × 24 in)

ALWYN CRAWSHAW

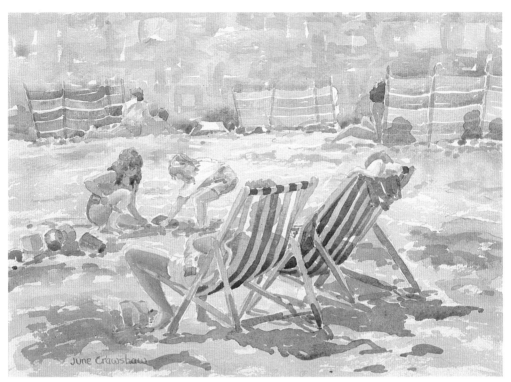

Deckchairs on the beach
Painted in the studio. Watercolour on Bockingford, 25 × 35 cm (10 × 14 in)
June Crawshaw

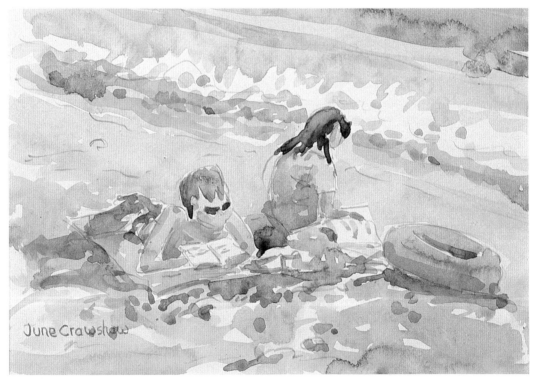

"It says here you don't get sharks in the Channel"
Painted on location. Watercolour on cartridge, 13 × 20 cm (5 × 8 in)
June Crawshaw

Oh what a beautiful baby!
Painted in the studio. Watercolour on Bockingford,
35 × 25 cm (14 × 10 in)
June Crawshaw

By the sea
Painted in the studio. Watercolour on Bockingford, 25 × 35 cm (10 × 14 in)
June Crawshaw

Eat up your vittles
Painted in the studio. Watercolour on Bockingford, 16 × 23 cm (6^1/$_2$ × 9 in)
June Crawshaw

You go your way, I'll go mine
Painted in the studio. Watercolour on Bockingford, 25 × 35 cm (10 × 14 in)
June Crawshaw

Polperro, Cornwall

Painted in the studio. Watercolour on Whatman 200 lb Not, 25 × 45 cm (10 × 14

June Crawshaw

Natalie and me by the sea

Painted in the studio. Oil on primed hardboard, 19 × 14 cm ($7^1/_2$ × $5^1/_2$ in)

June Crawshaw

HOLIDAY CHECKLIST

MATERIALS

For pencil

✓ Sketchbook
✓ 2B and 3B pencils
✓ Knife for pencil sharpening
✓ Putty eraser
✓ Elastic bands for holding down
 sketchbook pages

For watercolour

✓ Watercolour paper/sketchbook or pad
✓ Paintbox
✓ Brushes
✓ 2B pencil
✓ Knife for pencil sharpening
✓ Putty eraser
✓ Tissues for cleaning equipment
✓ Blotting paper, if used
✓ Water carrier with lid
✓ Water holder
✓ Elastic bands for holding down
 sketchbook pages
✓ Easel or board, if required

For oil

✓ Primed painting surfaces
✓ Tubes of oil paint
✓ Brushes
✓ 2B pencil
✓ Turpentine or Low Odour
 Thinners (not allowed
 on aeroplanes)
✓ Alkyd Medium or
 Gel Medium
✓ Dipper
✓ Palette
✓ Palette knife
✓ Tissues/rags
✓ Easel, if required

OTHER IMPORTANT ITEMS

✓ Carrying bag
✓ Plastic bag for protecting sketchbook/
 paintings
✓ Folding chair
✓ Wellington boots
✓ Camera and film
✓ Sunglasses
✓ Sunhat
✓ Suntan lotion
✓ Mosquito repellent
✓ Medicines for tummy upsets/
 headaches/cut fingers/insect bites
✓ Tickets
✓ Passport
✓ Travel insurance
✓ Foreign currency
✓ Maps and guidebooks
✓ Foreign phrase book/dictionary